Unknown New York

An Artist Uncovers the City's Hidden Treasures

Written and illustrated by

JESSE RICHARDS

Workman Publishing • New York

To Sienna Rose,
the most creative person I know.

Workman
Workman Publishing
Hachette Book Group, Inc.
1290 Avenue of the Americas
New York, NY 10104
workman.com

Workman is an imprint of Workman Publishing, a division of Hachette Book Group, Inc.
The Workman name and logo are registered trademarks of Hachette Book Group, Inc.

Design by Sarah Smith and Galen Smith

The publisher is not responsible for websites (or their content) that are not owned by
the publisher.

Workman books may be purchased in bulk for business, educational, or promotional use.
For information, please contact your local bookseller or the Hachette Book Group Special
Markets Department at special.markets@hbgusa.com.

Library of Congress Cataloging-in-Publication Data is available.

ISBN 978-1-5235-2411-2

First Edition September 2024

Printed in China on responsibly sourced paper.

10 9 8 7 6 5 4 3 2 1

CONTENTS

INTRODUCTION

When I was a kid, I loved exploring the woods and fields around our suburban New Jersey neighborhood, jumping over streams and running through tall corn. When I grew up, I moved to an even more rural part of New Jersey, in the northwest. With several state parks nearby, and the Appalachian Trail not far away, I used to go hiking in the forests every day after work. This was beautiful, relaxing, introspective, invigorating . . . and lonely. So I moved to Manhattan with a friend. It seemed like my situation had completely reversed: I saw lots of people, but was doing very little hiking and exploring. Eventually, I realized that my interest in exploring could transfer to the city; I even discovered that I preferred the urban type of exploration. In the beginning, my roommate and I would walk around on the weekends to find new restaurants or things to do. But we didn't go too far afield from our apartment on East 24th Street.

My decision to run an art group soon changed that. Twice a month since 2007, I've led artists around the city to sketch. Deciding to lead

the group was partly spurred by my frustration with available art classes in the city. You would think the only thing an artist ever needed to learn was how to draw naked people! I wanted a group to focus on landscapes. Using Meetup to organize, our new group started off drawing different spots in Central Park, so we called the group the Central Park Sketching Meetup. At first, it was just four or five folks awkwardly getting together and drawing whatever we felt like. After a few years, the group had grown quite large and I was more comfortable as a leader. We felt we had drawn as much of Central Park as we wanted to, so I ventured out looking for new spots. It went so well that I soon realized that a big reason the regulars kept coming back was to experience new places in the city.

Most members of the group were New Yorkers, some for their whole lives, and yet the city was still unfolding before them. The group turned out to be a great excuse to explore; without a compelling reason to get out of the house, it's easy to fall into a daily routine and not make time for novel events. I started to feel the pressure to challenge myself and meet the group's expectations, so I began rummaging through New York City history in books and online. And the places we drew got more obscure—and interesting.

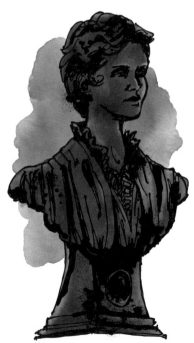

Bust of Alice Freeman Palmer, Hall of Fame for Great Americans

Fort Tryon Park

Today the group has more than eight thousand members and we've had hundreds of sketching adventures. It's certainly breathed life into my own art, which I had neglected before. Like a lot of members, I went to school for fine art but ended up with only a tangential job—having started as a web designer, I now lead a product team at a tech company, managing designers and developers. My main outlet for drawing became the group's biweekly treks. I've seen my art evolve a lot over the years, from pencil to ink to grayscale marker to watercolors to vivid iPad painting. I've gotten a lot faster, too, since I need to simultaneously draw and play host. Most of the sketches in this book were done in thirty to sixty minutes.

I definitely have my favorite places, and I hope you'll also discover yours. And the next time you're strolling in New York—or walking around anywhere, for that matter—stray off the beaten path. You never know what hidden secrets you may find.

—Jesse Richards

HIDDEN
HISTORY

New York City's rich history encompasses many different eras, and evidence of each can still be found throughout the city. The original Dutch settlement started at the southern tip of Manhattan, and you can see windmill motifs honoring this legacy in the architecture of many buildings downtown. Or, right nearby, go back even further and learn about the land's earliest cultures at the majestic National Museum of the American Indian. A few blocks away, visit Fraunces Tavern, the still-running restaurant where George Washington said goodbye to his troops. Farther uptown, you can learn some nineteenth-century history by visiting President Grant's tomb or the Mount Vernon Hotel, which faithfully re-creates life in the 1830s.

Moving into the twentieth century, New York has thousands of sites that honor and reference not just political history but pop culture, art, cultural history, and more. Explore some literary history by checking out the original Winnie-the-Pooh dolls that the books were based on. Or visit the park in the Bronx where Batman was created by two young men with big imaginations. See the newspaper headquarters where *Superman* was filmed, or visit an East Village bar that's been featured in dozens of TV shows and movies. Or visit one of New York's nearly two hundred museums, capturing an unimaginable array of topics—math, firefighting, skyscrapers, Houdini, sex, public transit, posters, and even food and drink.

Museums are obvious places to delve into history, but walking down any street in New York can uncover hidden tidbits, like classical statues tucked away behind a courthouse. So keep your eyes and ears open; you never know what you might learn.

The High Bridge

The craziest thing about the High Bridge connecting the neighborhoods of Washington Heights in Manhattan and Highbridge in the Bronx is not that it's high—you've probably driven over higher bridges—but that it's pedestrian-only. It's basically a long, thin, red sidewalk through the sky, and I admit I was pretty wary to look over the edge of it. It's capped by a huge octagonal castlelike water tower on the Manhattan side. Built in 1848, the bridge is New York's oldest, and was originally part of the Croton Aqueduct, which carried fresh water over the Harlem River into Manhattan. When that route was no longer needed, the bridge closed and fell into disrepair. It was locked up for more than forty-five years before finally being renovated and reopened in 2015. The shiny new bricks now gleam in the sunlight, which adds to the dizzying effect. They also radiate heat, so I don't recommend crossing the bridge in August. But in the spring, bring a picnic—there's a full park and cliffside walking trail on the Manhattan side.

*Between West 173rd Street, Washington Heights, Manhattan,
and West 170th Street, Highbridge, the Bronx*

The Daily News Building

If you loved the Superman films of the 1970s and '80s—still the best, in my opinion—this should ring a bell as the lobby of the Daily Planet Building that Christopher Reeve and Margot Kidder dashed through on their way to chase a story. It's not much of a stretch: It is actually the lobby of the Daily News Building, on East 42nd Street, and it's open to the public. The giant globe spins on its axis and completes a rotation every ten minutes—although when the building opened in 1930, the globe briefly spun the wrong way at first.

Coincidentally, the Daily News Building is across the street from the spiky glass Trylon Towers that look eerily like the frozen Fortress of Solitude. Consider stopping by for a Superman-themed tour of the city, which could also include Grand Central Terminal (Lex Luthor's hideout was underneath it) and conclude at Midtown Comics, around the block at East 45th and Lexington.

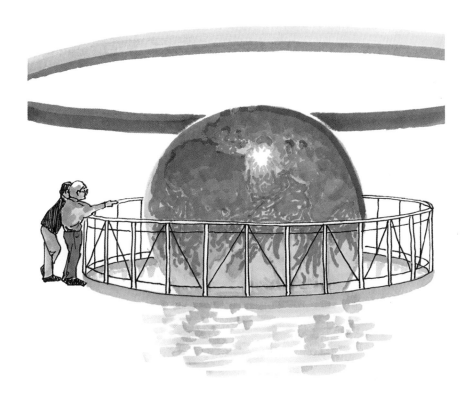

220 East 42nd Street, Midtown, Manhattan

The Mount Vernon Hotel Museum & Garden

The Mount Vernon Hotel is no longer a hotel but a museum representing life in New York for a sliver of time in the early 1800s. Located at East 61st Street, near the East River, this house/hotel was "uptown" and "out in the country" when it was built in 1799. It sits on land originally owned by Colonel William Stephens Smith, whose wife, Abigail Adams Smith, was a daughter of President John Adams. It's one of only eight surviving pre-1800 buildings in NYC, and its rooms faithfully re-create the past, specifically the era of 1826 through 1833, when the house was a hotel. Outside, there's a picturesque courtyard garden that's as quiet as the rest of the property. The museum puts on lots of special events—monthly lectures, children's storytime, candlelight holiday tours, and even a Halloween murder mystery—throughout the year, so check out its calendar online.

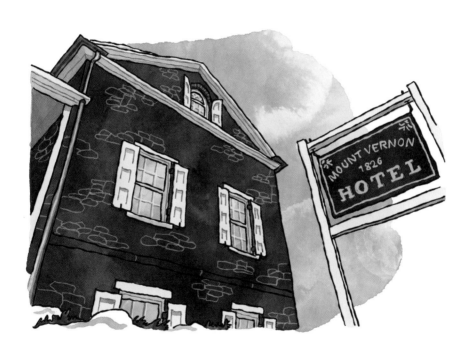

421 East 61st Street, Upper East Side, Manhattan

Grant's Tomb

If you happen to be walking along Riverside Park and stumble upon this towering building, you'll stop in your tracks. It's gigantic, the largest mausoleum in North America. It's severe and stark and rises up dramatically from a wide plaza dotted with similarly towering trees. The interior is strikingly solemn and imposing. You enter into a giant central dome as shown here.

Meanwhile, incongruously, a colorful 1970s public art tile bench wraps around the back of the building. It looks like a kid's version of the Gaudí balcony in Barcelona's Park Güell. It's fun and childlike, and could not possibly contrast more with the tomb.

FUN FACT: Who's buried in Grant's Tomb? This seemingly obvious question, once asked by Groucho Marx, has a surprising answer: no one. President Ulysses S. Grant and his wife, Julia Dent Grant, are actually entombed aboveground in matching sarcophagi in the building, not buried underneath the ground.

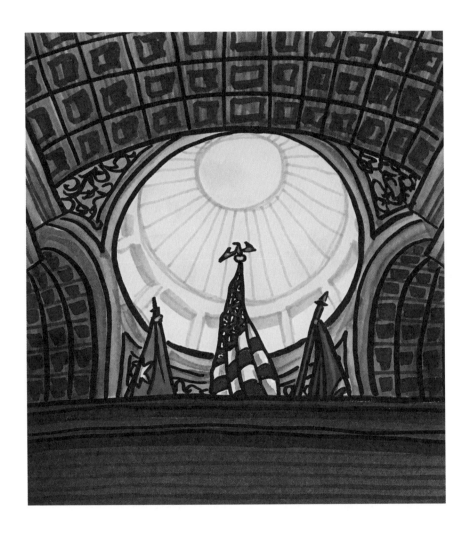

West 122nd Street & Riverside Drive, Morningside Heights, Manhattan

Hats at the Flatiron

When the Fuller Building—now better known as the Flatiron Building—went up in 1902, its elegance and unusual "flatiron" shape quickly made it one of the most iconic landmarks in New York. But it also received criticism for the treacherous gusts of wind that blew around the prow at East 23rd Street. This allegedly led to the phrase "23 skidoo," one of the nation's earliest and most ridiculous fad expressions, based on what policemen would yell at men trying to catch glimpses of women's up-blown dresses. Turns out the phrase may predate the building, but the legend stuck.

Hats blew off, too, and that history is represented in the form of 120 life-size hat tile mosaics, designed by artist Keith Godard, that line the walls of the subway station below the Flatiron. Each hat is labeled for its owner, a famous New Yorker from 1880 through 1920ish. Shown here, from left, are the hats of Samuel Clemens (aka writer Mark Twain), dancer Isadora Duncan, and Lillie Langtry, an actress. The neatest part is that each hat is on the wall at the appropriate height of its owner, letting subway riders step into the shoes (so to speak) of each turn-of-the-century celebrity.

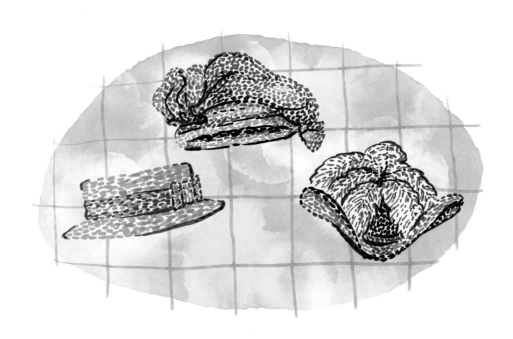

R/W subway stop at Broadway & East 23rd Street, Flatiron District, Manhattan

The Roosevelt Building

At the intersection of Broadway and East 13th Street sits the ornate and colorful Roosevelt Building, with friezes wrapping all around its pinkish-orange facade of brick, granite, and terra-cotta. In addition to the stand-alone scenes like the two mermaids in this drawing, the faces of devils and monsters weave in and out of the building's ledges and pillars. The colorful coral walls are complemented by tan accents and fir-green window trim. It's worth the trip to see the building, and you'll have a great excuse to visit one of its current occupants: Max Brenner Chocolate Bar, a restaurant with a chocolate-themed menu and clear tubes of melted chocolate running through the space.

The landmarked Roosevelt Building dates to 1894, but an even older Roosevelt home once sat next door on the corner of East 14th Street. That mansion, long since gone and now a bank, was owned by Cornelius Van Schaack Roosevelt. It is the site of a rare convergence of two presidents from different eras. In 1865, from one of the mansion's high windows, six-year-old Teddy Roosevelt watched President Abraham Lincoln's funeral procession march by through Union Square.

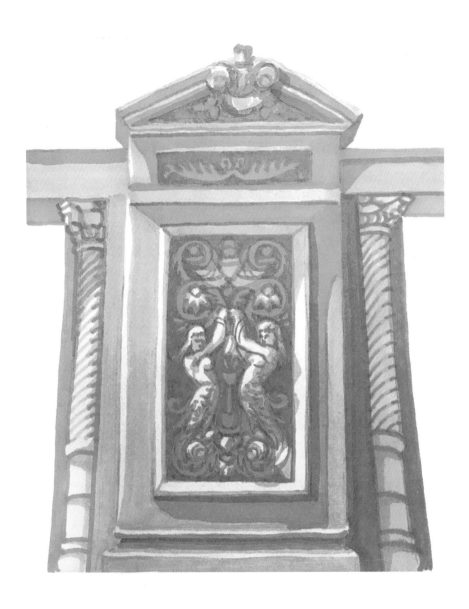

841 Broadway, Union Square, Manhattan

The Cable Building

The Cable Building is simultaneously imposing and delicate, with a beautiful, detailed facade of brick, stone, and terra-cotta. It once housed an amazing secret forty-six feet belowground. Four huge 1,200 horsepower Corliss steam engines powered the cable car system that ran the length of Broadway, with 125 cars carrying 100,000 passengers a day. Thought cable cars were only a San Francisco thing? Well, New York's didn't last long—only from 1893 until 1901. Electric trolleys, and then subways and motorcars, rendered the system obsolete.

The building itself is a rarity. It wasn't often that something as utilitarian as a power station was dressed in such finery—and it also housed seven floors of corporate offices. It was designed by the legendary architectural firm of McKim, Mead & White. (Which included the same Stanford White who designed the Hall of Fame for Great Americans, see page 44.) The main entrance sports this huge ornamental window flanked by two figures, each a whopping eleven feet tall, reminiscent of New York State's flag and official seal. The woman on the right used to hold a sword, but it broke off in the 1920s and was replaced with a flame to match the statue on the left.

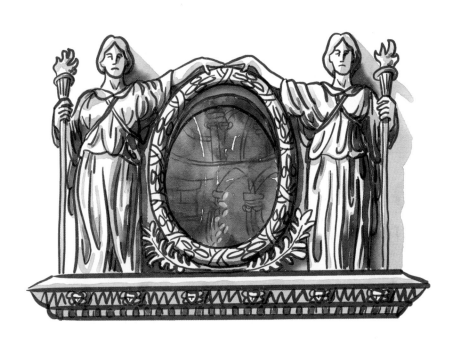

611 Broadway, NoHo, Manhattan

The New-York Historical Society

This museum is New York's oldest, dating back to 1804. The hyphen in "New-York" in its name isn't due to the overreach of spell-check; it's the archaic spelling of the city's name. That attention to detail can be found in all of this museum's delicate exhibits, from the bronze statues of Abraham Lincoln and Frederick Douglass guarding the steps of each entranceway to the intricate snowy model trains that zip through the lobby every winter. Two other permanent exhibits are worth the price of admission: *Meet the Presidents* is the name of the gallery that features artwork and objects of past presidents and a life-size re-creation of the Oval Office. There's also a huge two-story gallery of exquisitely glowing Tiffany lamps, shown in the drawing here. The entire sprawling space is cast in a shimmering ocean blue that shows off the stained glass beautifully.

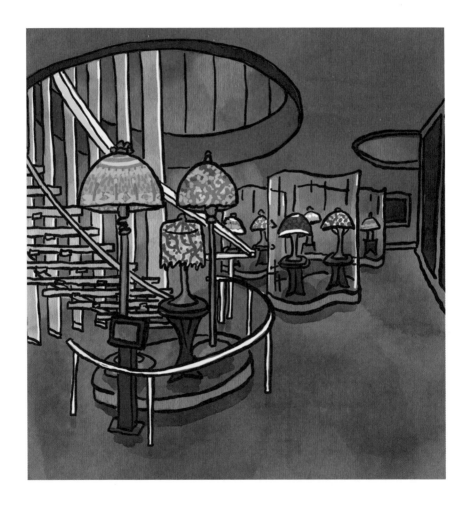

170 Central Park West, Upper West Side, Manhattan

The City Reliquary

An old-fashioned subway turnstile rotates with a *chu-chunk* to lead you into the weird, wild world of the City Reliquary. This unassuming storefront in Williamsburg, Brooklyn, hides one of the city's smallest museums, but it's certainly made the most of the space. The few small rooms are jam-packed. You'll find a Brooklyn seltzer bottle collection, a hundred different Statue of Liberty souvenirs, old hand straps from subway cars, memorabilia from the 1939 New York World's Fair, and a brick chunk from the Flatiron Building, shown here. And that's all just in the permanent collection. The museum also features rotating exhibits and hosts block parties, backyard concerts, film screenings, and other events, like Bike Fetish Day, the Havemeyer Sugar Sweets Festival, and Miss Subways, in which one lucky contestant takes home a crown that says "Delayed." The latter is an homage to the historic Miss Subways beauty contest that was held in the city from 1941 through 1976, but with a focus now on accepting contestants of all gender identities, ages (over eighteen), and body types.

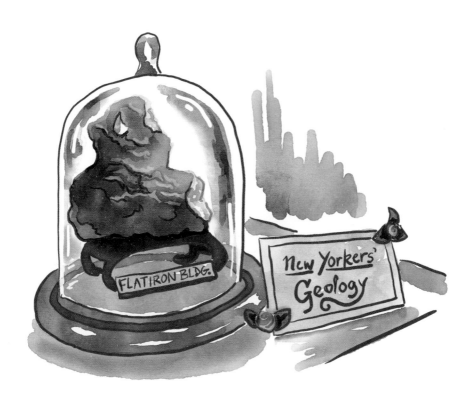

370 Metropolitan Avenue, Williamsburg, Brooklyn

The New York City Fire Museum

New York has many architecturally notable firehouses, and one of them also happens to be a museum. Whoever named it must have had a flair for the dramatic, choosing "Fire" over the more straightforward "Firefighters" or "Firefighting." The renovated 1904 firehouse on Spring Street holds hundreds of years of firefighting history. The garage hosts a parade of huge antique fire trucks, each one a weird, red steampunk skeleton looking wildly ineffective. This illustration is of Tiger Hose Company No. 8, a wagon transporting water, meant to be pulled by a horse. The upstairs is home to tools, uniforms, and countless historical photos hung salon-style (meaning filling every inch of the walls, from floor to ceiling). In addition to the regular and rotating exhibits, a separate 9/11 memorial pays tribute to the 343 firefighters who lost their lives saving others on that day.

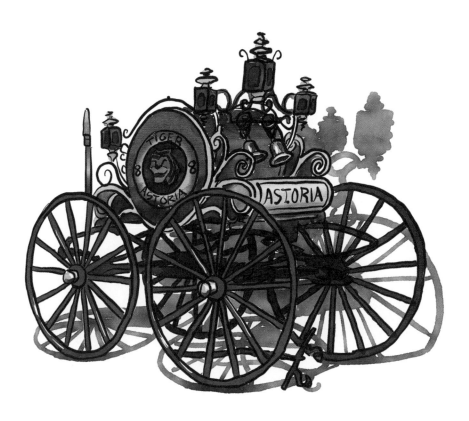

278 Spring Street, SoHo, Manhattan

The Shinran Shonin Statue

This statue might blend in with many others in the city if it weren't for the unusual pattern of red burn marks on its otherwise greenish-brown bronze. The source of the stains is what's shocking—the statue's original home was a mile and a half from the atomic bomb's blast in Hiroshima, Japan, in 1945. It has stood in New York since 1955, when Japanese industrialist Seiichi Hirose gifted it to the city. Depicting Shinran Shonin, the founder of the Jōdo Shinshū sect of Buddhism, it's now at a Buddhist temple by Riverside Drive, where Shinran stands silent and stern, seemingly watching passersby, a symbol of both devastation and the hope for peace.

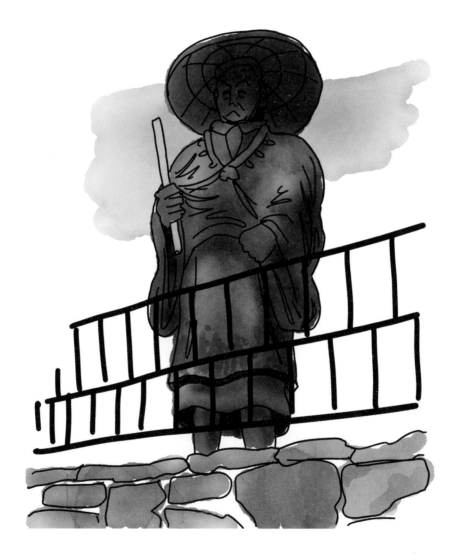

332 Riverside Drive, Upper West Side, Manhattan

The Ukrainian Museum

Little Ukraine, like many of Manhattan's ethnic enclaves, used to be bigger. Now it's confined to a few streets in the East Village, and even there it commingles with the rest of the city's diverse cultures. But it's anchored by the colorful Saint George Ukrainian Catholic Church, and the surprisingly comprehensive Ukrainian Museum a block away. The museum collection includes folk art, ceramics, textiles, historical artifacts, photographs, and contemporary art. The exhibits rotate regularly; I've seen one featuring works by Andy Warhol (whose parents emigrated from Ukraine), a showcase of small ceramic folk sculptures by contemporary artist Slava Gerulak, documentary photography from Russia's war in Ukraine, and a robust collection of pysanky—unbelievably ornate Ukrainian Easter eggs. The drawing here is of the display of eggs you can buy in the small gift shop.

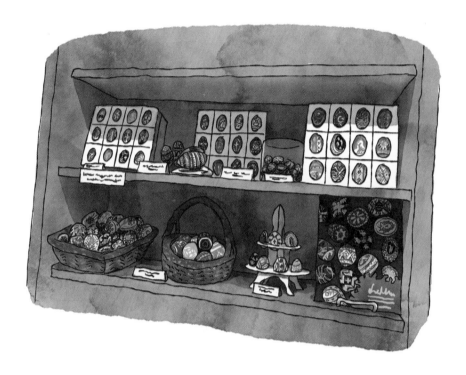

222 East 6th Street, East Village, Manhattan

St. George's Church

The beautiful St. George's Episcopal Church (whose parish is known as Calvary-St. George's) was built in the 1850s with a design based on German churches, and is considered one of the earliest and best examples of Romanesque Revival church architecture in the country. Its imposing clock towers had two huge spires, which were removed in 1889, possibly due to damage sustained in a fire in 1865.

Financier J. P. Morgan Sr., once the world's richest man, attended St. George's from the 1860s until his death in 1913. People at the time called it "Morgan's church," and more than fifteen hundred mourners filled it for his funeral. (Morgan was allegedly the inspiration for "Rich Uncle" Pennybags, the Monopoly mascot.) Morgan had enemies; anarchists hated him simply for his industrialism. The most shocking story of the church involved a man seeking to assassinate Morgan. The killer sat at the back during one Sunday service before suddenly shooting the doctor who happened to be passing the collection plate. The fleeing assassin's shots left a bullet hole in the wall that remains to this day. Sadly, Dr. James Wright Markoe died, but there was no chance of Morgan's being in danger. The assassin, later judged criminally insane and committed to an asylum, hadn't realized that Morgan had died seven years earlier.

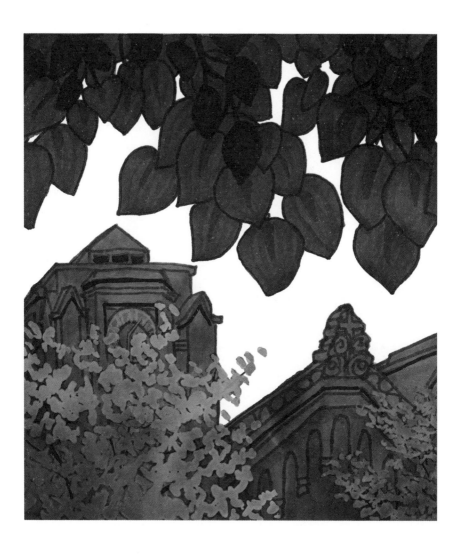

7 Rutherford Place, Stuyvesant Square, Manhattan

The Original Winnie-the-Pooh

The main branch of the New York Public Library is known for its marble guardian lions, Patience and Fortitude. But few people are aware that there are more famous animals by far to visit inside. In the Polonsky Exhibition Room in the main branch, in a big glass box in front of a blown-up map of the Hundred-Acre Wood, Winnie-the-Pooh and his friends are on display. These are the real deal—the original Pooh and Piglet and Kanga and more, owned by author A. A. Milne's son, Christopher Robin Milne, more than a hundred years ago. You can see how much the original Ernest Shepard drawings match them, much more than the later Disney versions. Who would have thought the first time little Christopher dragged these humble toys into the woods to play that eventually millions of children would join in their adventures?

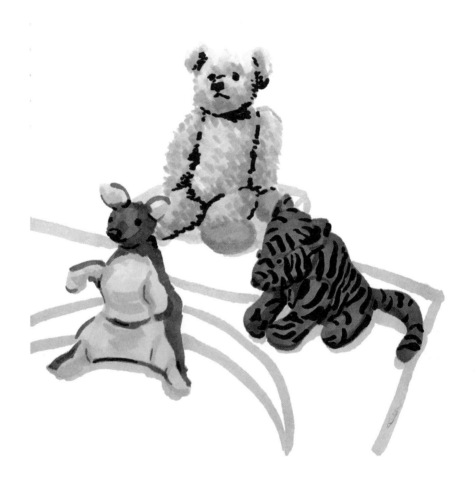

476 5th Avenue, Midtown, Manhattan

The Morris-Jumel Mansion

Imagine having your house commandeered by an army, and then later having it commandeered by the opposing army as fortunes changed in the war. The strategic high position of the Morris-Jumel Mansion— near the highest natural point in all of Manhattan—made it extremely appealing to military commanders during the Revolutionary War. Built in 1765, it's the oldest house in Manhattan and has hosted guests such as Thomas Jefferson, Alexander Hamilton, and both John Adamses (original and Quincy). And much more recently, Lin-Manuel Miranda wrote portions of his famous *Hamilton* in the house when he was granted a temporary writing space there—in Vice President Aaron Burr's old bedroom.

The grounds almost outshine the home—worn redbrick paths wind up and down hills, leading to hidden benches and a sundial. And then there's Sylvan Terrace, the street next door. It was originally the carriage drive of the Morris estate, but then twenty framed wooden houses were erected there in 1882. They are striking in their small size and symmetry, and mesh well with the antique lighting and cobblestoned street.

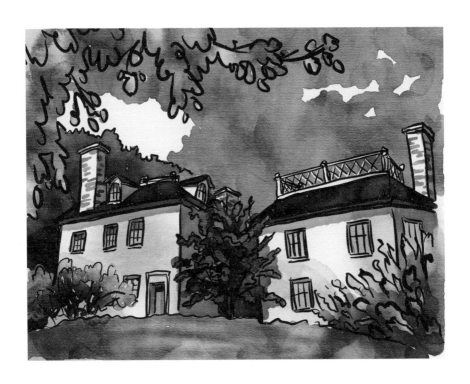

65 Jumel Terrace, Washington Heights, Manhattan

Justice and *Authority*

Philip Martiny's 1911 allegorical statues *Justice* and *Authority* used to have a prominent position flanking the New York County Courthouse, but now they're tucked away in the back. They sit in a little-used walkway between the New York County Supreme Court Building and the building that houses the United States District Court for the Southern District of New York. On one side sits *Justice*, holding a shield and scroll, while on the other is *Authority* (shown here), who holds a scroll in one hand and fasces, the Roman symbol of authority, in the other. The statues are enormous, dwarfing actual human size, and look out of place in the small space they now find themselves in. I love that *Authority* is sitting on a stack of books—a nice touch.

Martiny, a French American sculptor who lived from 1858 through 1927, also carved dozens of statues guarding the roof of the impressive Surrogate's Courthouse nearby, which you can see really well from the northeast corner of City Hall Park.

And when you're in the walkway where *Justice* and *Authority* reside, note a very different type of sculpture right next to them—a series of large dark stone blocks with Swiss-cheese holes that bubble with water. It's called *Sounding Stones*, a 1996 granite work by Chinese American sculptor Maya Lin, who also designed the Vietnam Veterans Memorial in Washington, DC.

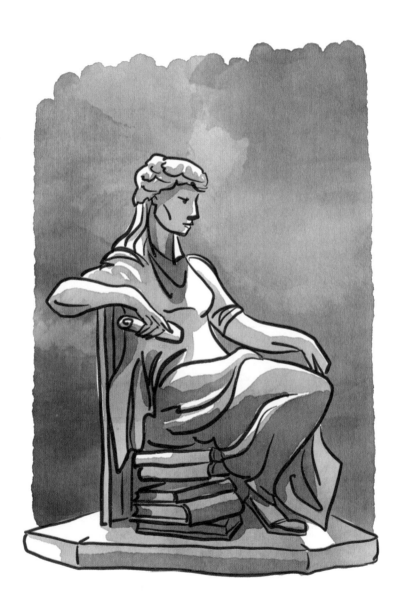

Near 158 Worth Street, Civic Center, Manhattan

The Soldiers' and Sailors' Monument

This hundred-foot-high pillar of a monument honoring the servicemen who fought for the Union in the Civil War towers over winding Riverside Drive. Unveiled in 1902, it has a classical marble structure based on a famous ancient (smaller) structure near the Acropolis in Athens. Busy on Memorial Day, the area is relatively empty the rest of the year. Perhaps the most interesting and unique parts of the monument are its surrounding terraces. Although never finished, there are several walkways and flat plateaus covered in intricate chess-patterned stonework both in front of and behind the monument. They serve as a fittingly tranquil lookout to study the Hudson River below.

West 89th Street & Riverside Drive, Upper West Side, Manhattan

Mail Chutes

New York has two nostalgic postal service secrets, one vertical and one horizontal. Skyscraper mail chutes let you drop mail from a top story and have it plummet to a mailbox on the ground floor. This allowed the postal service to pick up from just one box per building. James Goold Cutler invented the chutes in 1883, and his patent, combined with the golden age of skyscrapers, sent business booming to the tune of more than sixteen hundred chutes. The Cutler Manufacturing Company took pride in customizing each one—an art deco box for the Empire State Building, a grand golden one for the St. Regis hotel. There are more than nine hundred chutes still in use today. This illustration is of one I found in an office building on the Upper West Side.

Now take the mail chute concept and expand it horizontally, and you get the second secret: a pneumatic tube mail system. Using cylinders pushed through tubes by compressed air, the mail used to zip underground to the post office. Operating from 1897 through 1953, the network stretched the entire length of Manhattan and across the Brooklyn Bridge into Brooklyn as well. At its peak, more than ninety-five thousand letters were moved through the system each day, and they took only four minutes to get crosstown from the post office to Grand Central. Alas, the system was incredibly expensive to service and maintain and was phased out, in favor of using cars to carry the mail throughout the city.

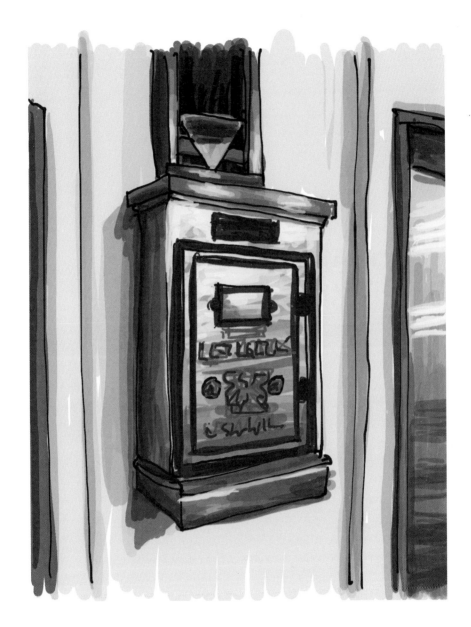

Mail chutes are located throughout the city.
The Empire State Building is at 20 West 34th Street, Midtown, Manhattan.

Edgar Allan Poe and Batman

At the north end of the small Poe Park in the Bronx sits the former home of—you guessed it—famed writer Edgar Allan Poe. It's a ramshackle white cottage, dating back to 1812. Poe lived here from 1846 through 1849, probably paying about eight dollars a month in rent. His wife, Virginia, also his cousin, passed away here in 1847. Two years later, at age forty, Poe would be found delirious on the streets of Baltimore, dying later that night of unknown causes.

Nearly a hundred years later, in the park next to the cottage, two young creators used to sit and brainstorm and write. This is where Bob Kane and Bill Finger dreamed up Batman, Robin, Catwoman, the Joker, and all the rest of the Gotham City characters and mythos. ("Gotham" was originally a nickname for New York City, first used by Washington Irving in 1807.) Kane received credit on every one of the thousands of Batman comics published since 1939, but until recently, Finger's contributions were neglected and overlooked. In 2017, some overdue recognition was finally granted when the short street on the south border of the park was renamed Bill Finger Way.

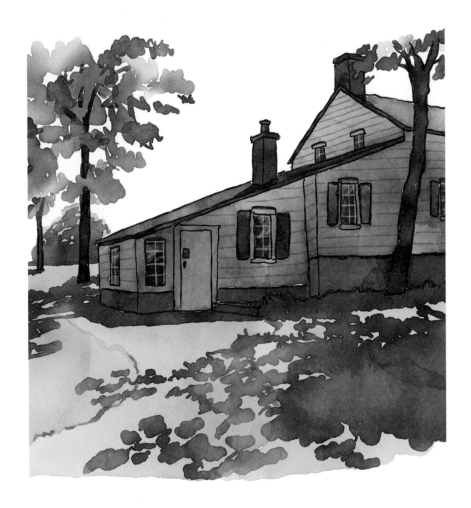

Edgar Allan Poe Cottage, 2640 Grand Concourse, Fordham, the Bronx

The First Hall of Fame

When the Munchkins frantically sang to Dorothy that she'd "be a bust, be a bust, be a bust in the Hall of Fame!" they weren't talking about a tribute somewhere in Oz. Believe it or not, they were referring to the Bronx. On the campus of Bronx Community College, part of the City University of New York, in a grand classical building on a high bluff overlooking the Harlem River, stands a long, open-air colonnade of one hundred statues. This literal "hall" of fame was the first ever in the United States. Each bronze bust depicts an exemplary American, spanning from Benjamin Franklin to Jackie Robinson, in wide-ranging fields such as art, politics, inventing, and teaching. The entries were voted on by a committee of representatives from each state in the country.

The Hall of Fame for Great Americans was designed in 1901 by famed architect Stanford White. As of this writing, the hall is undergoing repairs and is temporarily closed to the public. Hopefully it will reopen soon. In the meantime, you can still look up at the hall and see the statues and the grandeur of the building itself from the road that curves around the back of the hill it sits upon.

Bronx Community College, University Avenue & West 181st Street, University Heights, the Bronx

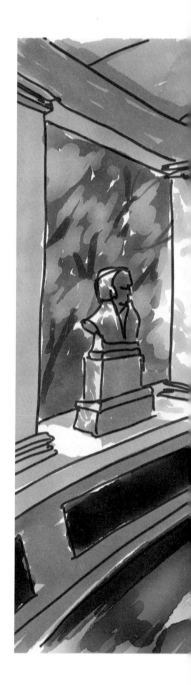

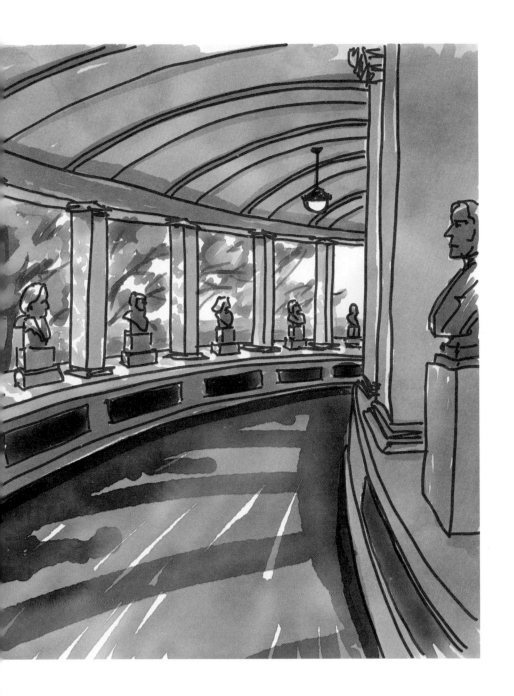

Fraunces Tavern

This downtown tavern where George Washington said an emotional farewell to his troops after the Revolutionary War is still a working restaurant, with dramatic wooden ceiling beams, chandeliers, and long family-style tables. After 250 years, even being flooded during 2012's Hurricane Sandy couldn't keep it down. (There's a waist-high line on the wall of the dining room marking how high the water rose, as if to proudly spite the hurricane.) The upstairs floors are now a museum devoted to Washington and his era. There are rooms decked out in period furnishings, a large room of Revolutionary War–era American flags, paintings and sculptures of Washington, and more. One temporary exhibit I saw there was dedicated to the French war hero Lafayette—whose real name, it turns out, is Marie-Joseph-Paul-Yves-Roch-Gilbert du Motier, marquis de La Fayette. Another cool exhibit called *Cloaked Crusader* showcased every time George Washington was featured in a comic book. Perhaps the strangest piece in the museum's collection is a portion of Washington's actual dentures, made out of ivory.

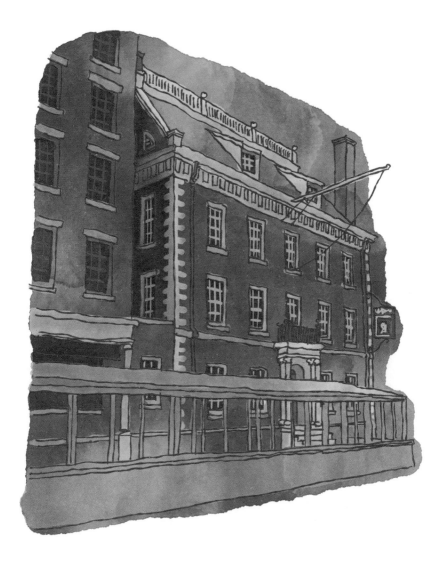

54 Pearl Street, Financial District, Manhattan

HUMBLE
PARKS

In addition to Central Park, New York has a series of well-known, robust parks that serve as hubs throughout the city: Bryant Park with its ice-skating rink next to the New York Public Library; Washington Square Park with its famous arch and crowds of New York University students; Battery Park, where you can stand in line all day to see the Statue of Liberty; and more. Those are all easy to find on the map. But did you know there are more than a thousand parks across the five boroughs? Some of them are enormous but out of the way, like Fort Tryon Park, while others are tiny but nestled in the heart of Midtown, like Greenacre Park, a sanctuary for office workers on their lunch hour. Many of the parks are neighborhood destinations, like cozy Stuyvesant Square, frequented mostly by residents of the surrounding few blocks.

This chapter focuses on the lesser-known of these thousand green spaces, parks that aren't ostentatious or crowded. Choosing a park to visit can be a fun challenge; it all depends on what you're looking for. In the mood for a sculpture garden full of amusing little creatures? Or would you like to see some beautiful tile art surrounding a charming fountain? Need a good dog run? There's a park for that. Or a cool carousel for the kids? There's a park with one of those, too, and a park for strolling by the water or chilling out on a sunny lawn. Parks are an essential respite from New York's (in)famous hustle and bustle, and whatever your preferred way to relax, you can find a perfect fit.

Wagner Park

The entire southern tip of Manhattan is a strollable series of large interlocking parks. From the Battery, you can walk west to Robert F. Wagner Jr. Park, South Cove, Pumphouse Park, North Cove Marina, Rockefeller Park (featuring the Tom Otterness sculpture garden called *The Real World*), and Teardrop Park. There's a tall wooden structure in Wagner Park that provides a panoramic view across the harbor to Ellis Island and the Statue of Liberty. But I chose to drop my view for this sketch to look down on the formal gardens below. Robert F. Wagner Jr. was a three-time mayor of the city, from 1954 through 1965. This park was named after him when it opened in 1996 because he had been instrumental in negotiating the original plan for this neighborhood, Battery Park City.

20 Battery Place, Battery Park City, Manhattan

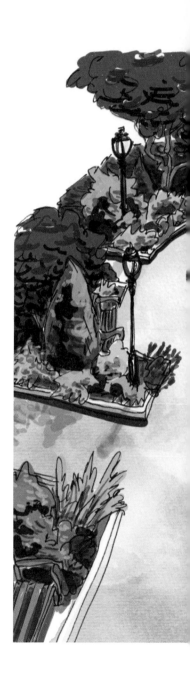

The Pier 62 Carousel

Did you know that New York City has more carousels than any other city in the world? There's the glorious Central Park Carousel with fifty-seven intricate horses, featured in *The Catcher in the Rye*. There's Jane's Carousel, sitting proudly in Brooklyn Bridge Park, with forty-eight beautiful and unique horses. And then there's the Pier 62 Carousel, in Hudson River Park, with . . . no horses?

No regular horses, but instead we get seahorses and horseshoe crabs. And there's a turkey, a fox, a Canada goose, a raccoon, a bear, a sea turtle, some sturgeons, and even a skunk. The seal looks particularly bemused, and the lobster is facing backward. All in all, there are thirty-three hand-carved animals. What do the members of this menagerie have in common? They're all native to the Hudson River Valley. It's a fun theme for this hidden gem of a ride that has great views of both the Hudson River and the Manhattan skyline.

My daughter, Sienna, is shown here, nine years old, riding the carousel on one of our weekend outings around the city. It's easy to make a day of it: Pier 62 is perfectly located near Chelsea Piers recreational complex, the High Line, and the sprawling food court of Chelsea Market.

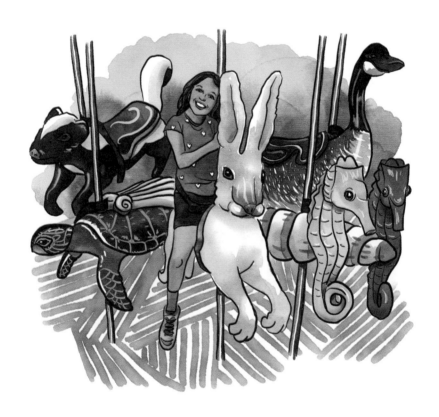

Pier 62 at West 23rd Street, Chelsea, Manhattan

Greenacre Park

It's unlikely you'll stumble upon this beauty by accident. Tucked away in a single building lot on East 51st Street between 2nd and 3rd Avenues is a public park that's privately owned and maintained by the Greenacre Foundation. Designed by Hideo Sasaki in 1971, Greenacre Park features lots of chairs for sitting and relaxing, often used by local workers getting out of the office for a bit. The fragrant hyacinths and daffodils in the spring and the pumpkins and corn decorations in the fall all point toward the park's defining feature: a huge waterfall against the back wall. Sculpted from large granite blocks, the waterfall is twenty-five feet tall. Despite its quiet and oasis-like vibe, Greenacre Park hosts more than 200,000 visitors annually and is listed in the National Register of Historic Places.

217 East 51st Street, Midtown, Manhattan

The Jacob Wrey Mould Fountain

Jacob Wrey Mould was a true Renaissance man of the nineteenth century. He was an architect, illustrator, linguist, and pianist. He's most well known for his collaborations with Calvert Vaux, the codesigner of Central Park. Mould contributed to lots of pieces of the park, including the grand Belvedere Castle, many bridges, and the carvings all around Bethesda Terrace. Those carvings include a sunset, a little house, lifelike birds, and even a witch. Mould and Vaux also worked on the designs of the Metropolitan Museum of Art and the American Museum of Natural History.

This 1871 fountain Mould designed resides in City Hall Park, nestled between trees. It sat in this spot for fifty years before it deteriorated and was moved to the Bronx, where it fell into complete disrepair. Only with the renovation of City Hall Park in 1998 was it finally restored and then transplanted back to its original home. This drawing focuses on the ornate corner lamppost, one of the standout features of the fountain, which also includes great arcs of water and four additional pools around its edges. The park is well worth a visit to see the fountain, majestic City Hall, and the architecturally marvelous Woolworth Building across the street.

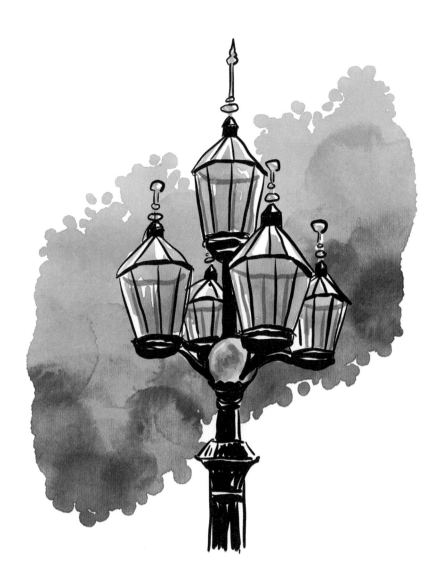

43 Park Row, Civic Center, Manhattan

Domino Park

Many of New York's industrial dockyards and waterfronts have been transformed into parks in recent decades, and perhaps none represents this trend as quintessentially as Domino Park. That's because it took over the space of the classic Domino sugar refinery in Williamsburg, Brooklyn. The park is exceptional in the way its design repurposed huge factory equipment from the site—like three-story-tall syrup collection tanks, loading cranes, and an elevated walkway that stretches most of the quarter-mile length of the park. Even the playground is designed as a parallel of the sugar refining process, letting kids climb from the "sugar shack" to the "masher tower" to the "centrifuge," with slides that look like industrial pipes and casts of original factory valves. Oh, and all these structures are bright, robin's-egg blue. Enormously popular, the park opened in 2018 and in its first two years saw 2 million visitors.

The burbling ground fountain shown here is a big hit with the squealing kids who run through it. It's especially impressive at night with lights radiating up from underneath the spray.

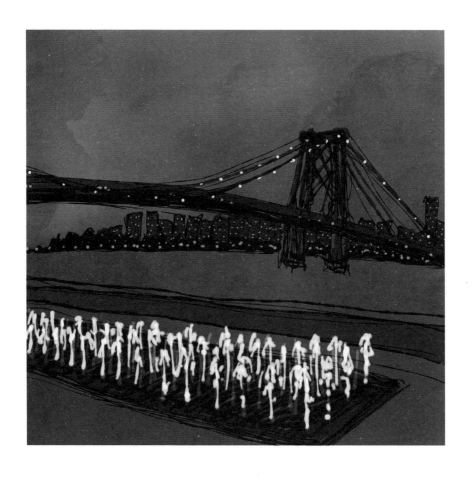

15 River Street, Williamsburg, Brooklyn

Stuyvesant Square

This neighborhood park hosts a grand statue of Peter Stuyvesant, the last Dutch director-general of New Amsterdam (as New York was once called). He built the wall on Wall Street (it used to be the border of the city) and expanded the city northward, but he was also known for his religious intolerance. The majestic statue of him, from 1941, is by Gertrude Vanderbilt Whitney, a renowned sculptor and founder of the Whitney Museum of American Art. I used to have a commute that took me past the statue, and I was always curious about how Stuyvesant lost his leg. Years later, my wife and I took a vacation to Saint Martin. The island is half Dutch and half French, and centuries ago it was fought over by not only the Netherlands and France but Spain as well. We stayed on the Dutch side and one day went hiking way off the beaten path. We ended up at the top of a tall cliff with high grasses and a dazzling view overlooking the bay. A small plaque on a pedestal stood alone at the top of the cliff. It read, "This marks the spot where Peter Stuyvesant lost his leg, by cannonball." This gruesome incident happened when Stuyvesant led an attack on the island to recapture it from the Spanish. It was when he was convalescing back home in the Netherlands that Stuyvesant received his wooden leg, and a new assignment to govern New Amsterdam.

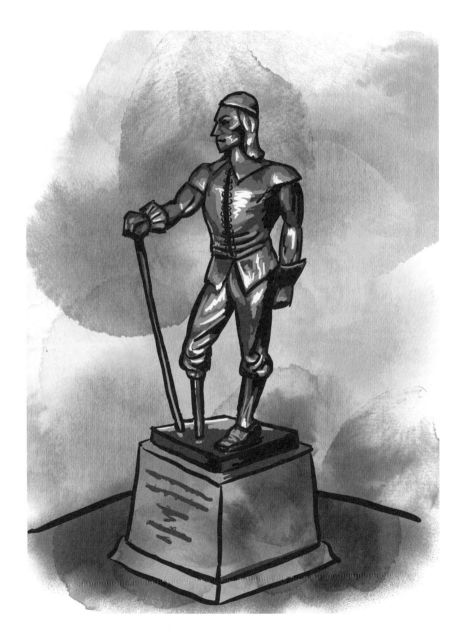

9 Rutherford Place, Stuyvesant Square, Manhattan

The SeaGlass Carousel

With its jaunty nautical music, the SeaGlass Carousel is lively but surprisingly soothing, as it seems to submerge you in a different world. Since 2015, the carousel has delighted and surprised visitors to Battery Park. Everything about it is ocean-themed, starting with the huge metal shell-turned-roof of the building itself. Riders sit inside glowing, transparent fish that bob up and down, spinning through a sea of lights and music.

The carousel evokes pure joy, but there is one bittersweet note. The structure is an homage to the old New York Aquarium, which for forty-five years, starting in 1896, was prominently housed in nearby Castle Clinton and was for a time the most popular attraction in New York. In 1941, power broker Robert Moses closed and demolished the aquarium. He was even halfway successful in razing the historic castle until federal orders stopped him. The SeaGlass Carousel brings back a bit of the magic of the aquarium, but in reverse. You're the one on the inside, floating and peering out as if from the fish's point of view.

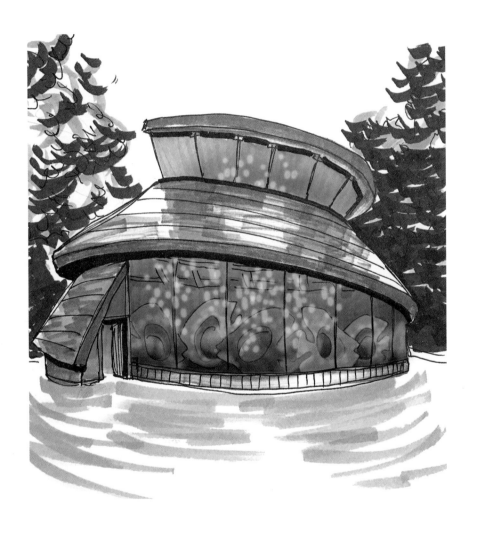

In Battery Park, Water Street & State Street, Financial District, Manhattan

Teardrop Park

Nestled between tall buildings in Battery Park City, the small Teardrop Park is almost like a disorienting but beautiful maze. All of its features—huge metal slides within trees that descend to a sand playground, a tunnel through a granite wall, a picnic hill, and paths through the woods—are surprising when you encounter them for the first time. The centerpiece of the park is this gentle, innovative trickling waterfall, here enjoyed by my then two-year-old daughter as my wife watches. The sedimentary rocks were brought in from northern New York State and stacked to resemble a natural formation. They glisten with little icicles in the winter. The waterfall is a one-of-a-kind structure that perfectly combines a clearly constructed, orderly shape with a natural, organic feel.

Warren Street, Battery Park City, Manhattan

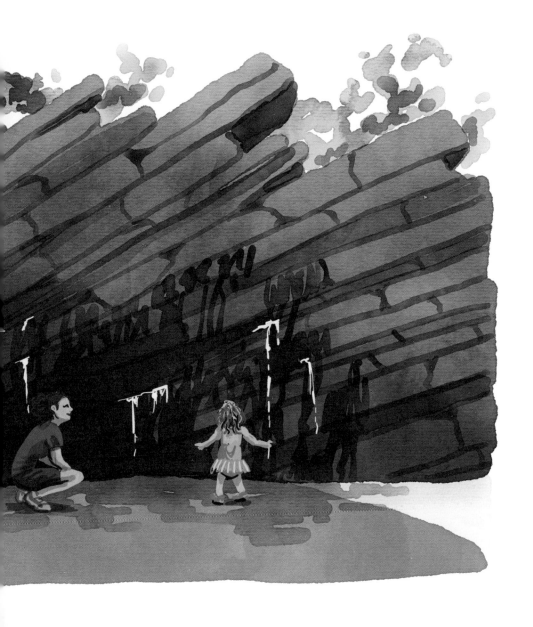

The Real World

The Real World is an exceptionally creative artistic landscape—and you can often have it all to yourself. This sculpture park is half playground and half art exhibit, and sits at the back of Rockefeller Park in Battery Park City. Populated with the work of a single artist, Tom Otterness, who also created an abundance of sculptures for the 14th Street/8th Avenue subway station, it's one of the best places to take kids in the city. There's a bubbling river you can turn on and off, structures to climb on, and little bronze people all around. Some of the figures are a foot high or taller, and some are weird, long-nosed animals, but most are roly-poly five-inch-high statues. They ride turtles, write with giant pencils, push coins around, and hide in caves.

And if you look closely, you'll see that the figures act out a subtle theme of financial inequality, with coins covering the ground and rich misers playing fiddles while they step on tiny peasants. The artwork's name seems to imply that real-world seriousness and issues have been brought into the playground. I love the way Otterness was able to convey a message about social injustice through the means of play.

River Terrace & Chambers Street, Battery Park City, Manhattan

Glick Park

A tiny park on the east side of Midtown, Glick Park is humble and hidden. It's remarkable for a few reasons—one is its gorgeous river views, and another is the unusual entrance. Because it sits on the other side of the elevated FDR Drive, a zooming highway, you need to duck underneath and pass through a darkened path. It's not well designed for pedestrians, as you can see in this sketch of the overlapping streets and buildings that mark the entrance to the park. Once you reach it, though, you'll find surprisingly lush trees and flowers in planters lining a long, scenic path along the East River. Much of 1st Avenue in this part of the city is lined with medical centers, and Glick Park sits behind them, which made it an ideal filming location during the five-season run of the TV medical drama *New Amsterdam*.

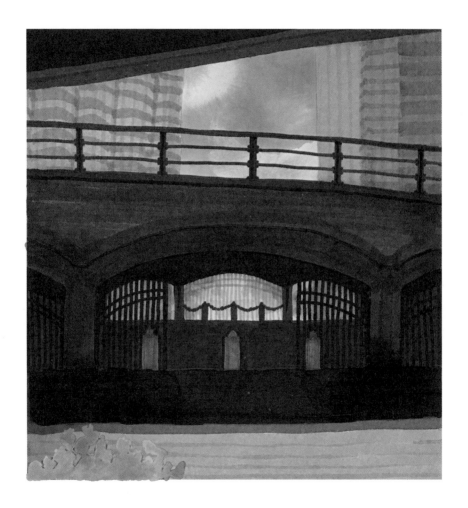

East 37th Street at East River Esplanade, Midtown, Manhattan

Bella Abzug Park

I learned about "Battling Bella" Abzug only recently, but her storied career is one more New Yorkers should know. This Bronx native was an early leader of the women's rights movement, a lawyer, and a member of the US House of Representatives. As a congresswoman, she introduced the first federal gay rights bill in 1974. She ran for US Senator of New York in 1976 (she lost by less than 1 percent!), and then ran for mayor of New York City in 1977. She lost that race, too, but made a name for herself and her causes with her passion, wit, and presence. She was known for her flamboyant hats, but when complimented, she'd respond, "It's what's under the hat that counts!"

The city finally acknowledged her accomplishments by putting her name on a park. Bella Abzug Park is the centerpiece of the newly developed Hudson Yards area of Manhattan. It's a nice park—several blocks of benches, tables, grassy areas, climbable structures for kids, and meandering circular fountains. You can also see the impressive tortoiseshell entrances to one of the city's newest subway line extensions. Hudson Yards is very present in the background, with its controversial tourist attraction—the towering Vessel.

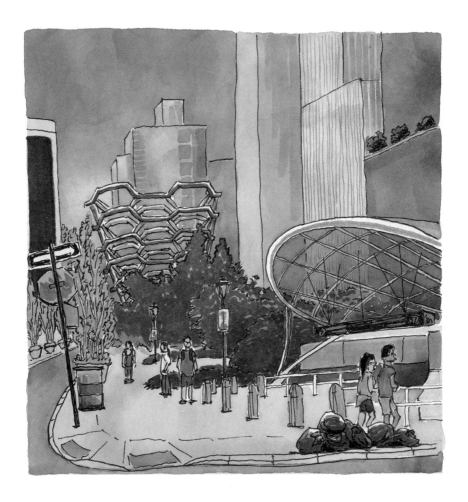

542 West 36th Street, Hudson Yards, Manhattan

Elizabeth Street Garden

"Help save the garden!" That's the rallying cry of the volunteers trying to rescue this one-of-a-kind sculpture park from demolition and redevelopment. The one-acre park is one of very few green spots in the NoLita neighborhood, and it's not easy to find. It nestles quietly between buildings, hidden by trees. But if you walk in, you'll enter a cozy nest of gravel paths dotted by dozens of pedestaled statues, like this limestone lion. Mismatched benches, vases, wind chimes, low brick walls, and a lush peach tree add to the homemade, DIY feel of the park. You wouldn't believe the number of wonderful and weird things to sketch there. The garden started in 1990 as overflow from owner Allan Reiver's antiques shop next door, and more and more sculptures were added over the years.

Several years ago the City Council voted to redevelop the garden into senior housing, but so far their efforts have been unsuccessful as the garden and neighborhood continue to fight back.

Park is near 209 Elizabeth Street, NoLita, Manhattan

Sutton Place Park

Sutton Place Park is actually a series of parks, each at the end of a different street, some of them barely more than tiny paved lots. When I first discovered them while walking with a friend, it felt like trying chocolates from an unlabeled box—some were delicious, and some were duds. The one on Sutton Place and East 57th Street is a winner, with luscious landscaping and a panoramic view of the East River, Roosevelt Island, and the 59th Street Bridge. The centerpiece is a bronze statue of a wild boar. Turns out it's a replica of a famous Renaissance statue in Florence by sculptor Pietro Tacca titled *Porcellino: Porcellino* means "piglet," which is a bit of a stretch for this imposingly monstrous creature, reaching six feet tall on its base. As a bonus, the base is decorated with other critters: mice, crabs, snakes, lizards, frogs, and snails, squirming over one another and around the boar's outstretched hooves.

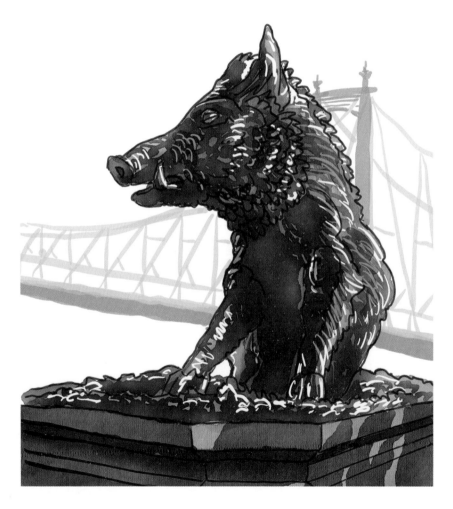

Sutton Place & East 57th Street, Manhattan

Fort Tryon Park

The huge Fort Tryon Park is certainly no secret to locals, but not many out-of-towners travel all the way up to the Washington Heights neighborhood to see it, even though the park hosts the Metropolitan Museum of Art's Cloisters museum—a collection of medieval art in a castle-like setting. What is now Fort Tryon Park was the site of the Battle of Fort Washington during the Revolutionary War, and it was during this battle that Margaret Corbin—the first woman to fight in the war—was injured. (The southern park entrance is now named after her.) Then, for more than a century, the area hosted large country estates until financier and philanthropist John D. Rockefeller Jr. bought them up in the 1920s and turned the land into a park for the city. There are fragrant flower gardens, and many paths like this one, winding along the Hudson River. The park also has a wonderful sitting and meeting area. It's like a plateau in the middle of trees, with benches for gazing at the grand views of the Hudson and room for locals to do tai chi. (Rockefeller purchased the land across the Hudson just to preserve the views.) I picked this spot to draw because I loved the canopy of leaves casting shadows over the path.

741 Fort Washington Avenue,
Washington Heights, Manhattan

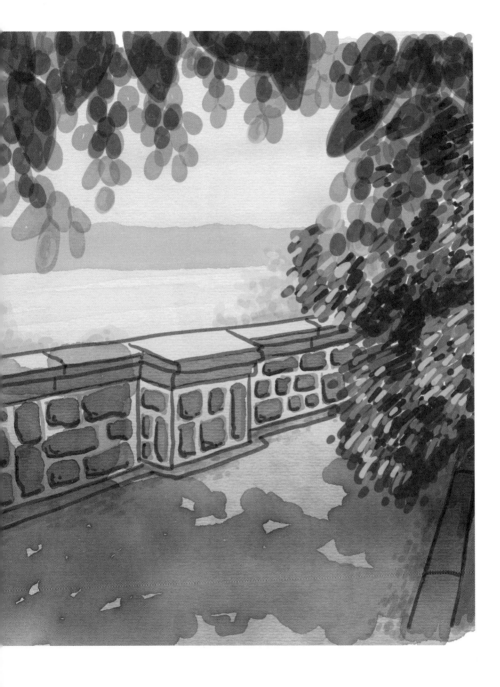

Stuyvesant Cove Park

Manhattan's West Side has long had a series of interconnected parks, bike paths, and green spaces that include a carousel, kayaking, miniature golf, normal-size golf, and a trapeze school (yes, a school where you learn trapeze arts—or just swing for fun and land in a net). The East Side never had such a coherent plan, with neglected parks scattered along the water's edge. Recent years have seen a big push to fix this, though, and Stuyvesant Cove Park, which runs along the East River from East 18th Street through East 23rd Street, is a great example. It's a modest, clean, and well-designed spot frequented mainly by locals, with joggers, dog walkers, and a few optimistic fishers. Being an East Sider myself, I'm quite partial to it. It even has a new ferry landing, with ferries commuting down to Wall Street and as far north as the Bronx. And this sandy outcropping, with its picturesque remnants of a pier, frames a view across the river to the new skyscrapers of Williamsburg, Greenpoint, and Long Island City.

24-20 FDR Drive Service Road East, East Side, Manhattan

The Evangeline Blashfield Fountain

The backs of most T.J. Maxx stores in the world probably feature some dumpsters and employee parking spots, but there's at least one with a magical surprise. Hiding behind this store, in the shadow of the 59th Street Bridge, is a tiny park with a stunning tile fountain. To say the park is hidden is an understatement; I've never seen another soul in it. (You can also enter it from East 59th Street.) The tile mosaic stands majestically at the end of the park, featuring the spirit of Abundance with a cornucopia overflowing with plums and apples and squash. Below the tile, a carved ox's head spits out the water.

In the 1910s and earlier, this was the site of a huge farmers market. Shocked by its poor sanitation and lack of clean drinking water, activist and advocate of the arts Evangeline Blashfield set out to dedicate a fountain for the market. Her husband, an artist, did the tile work, and Evangeline became his model for Abundance. Sadly, she didn't live to see the fountain finished, passing away from the 1918 Spanish flu right before its dedication. The mosaic fell into disrepair over the next century, before finally being restored to its original sparkling glory in 2003. Spend some time with Evangeline on a quiet sunny day as the fountain glistens in the sunshine, the traffic speeds by, and time stands still.

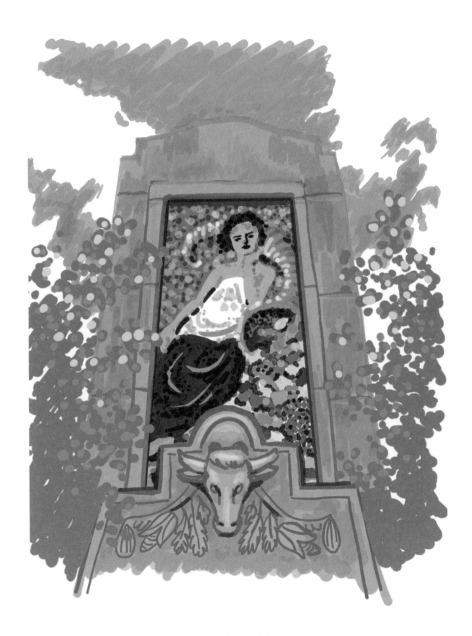

Next to T.J. Maxx, 407 East 59th Street, Manhattan

Peter Detmold Park

This is almost a secret park—it's *that* hard to find—but the hunt is fun. One side of the park borders the FDR Drive, so you can't enter the park that way. One entrance is hidden at the end of a sidewalk on one of the highway's exit streets, which is not particularly safe for pedestrians. The only entrance left is up on a hill overlooking the highway and the East River, a beautiful plateau of ritzy houses called Beekman Place. But even if you happen to be on Beekman Place, you can't see the park, which is below street level. The only clue is a small sign on a low fence at the end of East 51st Street that directs you to a set of narrow stairs winding down to the park. From there you can also take a walkway over the FDR to a nice but very short tree-lined path right along the river. The park itself is lovely—there's an elegant gazebo and trellises with climbing roses and other flowers. There are chess tables and a dog run, and one apartment building on the north edge of the park looks a lot like a castle. It's a relaxing respite in a spot where no one would think to look. It's named after a onetime resident of nearby Turtle Bay Gardens, which is another nice place to stroll.

454 East 51st Street, Midtown, Manhattan

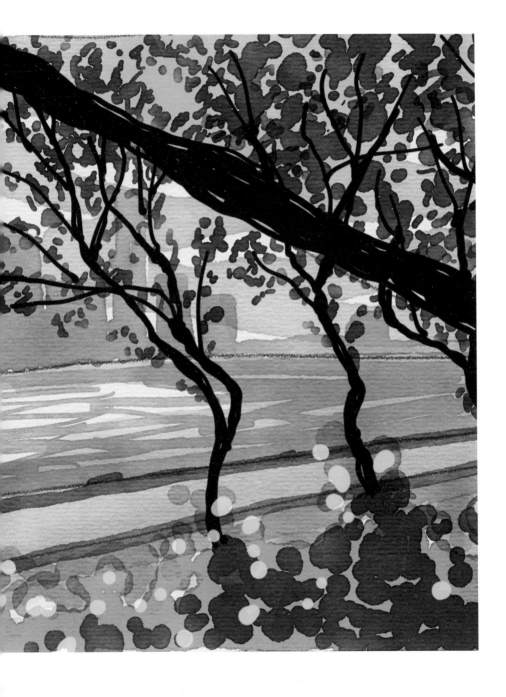

South Cove

South Cove is the most tranquil of the series of parks that make up the Battery Park City Esplanade, which runs from the bottom tip of Manhattan up through Tribeca. Unlike Battery Park itself, which floods with tourists waiting in line for the Statue of Liberty ferry, South Cove is just a humble walking path along a small stretch of New York Harbor. You can find it at the end of 1st Place, 2nd Place, and 3rd Place, tiny streets at the south end of Battery Park City. Oasis Park, an even tinier portion of the cove, stands out for an unusual series of circular wooden piers. They're arranged in an artistic pattern, not designed for mooring boats at all. And then there's the truly unique steel structure at the entrance, with a grand double set of stairs leading up to a tiny lookout perch holding . . . a single bench. The view is worth the climb, and it's fun if you get the bench to yourself.

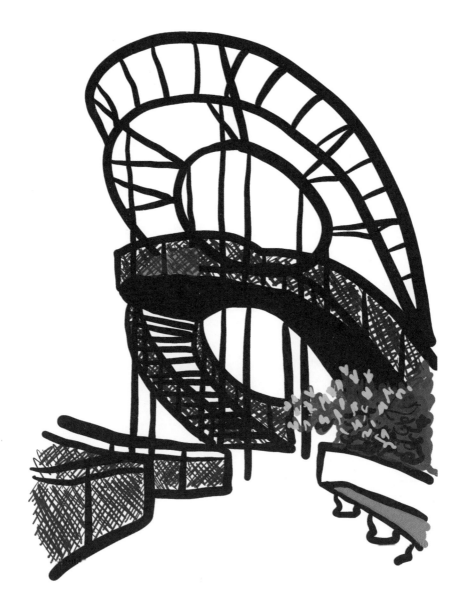

50 Battery Place, Manhattan

ON THE
STREET

Walking is the only way to truly see New York. With its wide sidewalks jam-packed with stores and restaurants, and broad coverage of reliable public transportation, millions of the city's residents don't need to own a car. Walking isn't just good for you and good for the environment, it also opens you up to bursts of serendipity. The locations here are all secrets sitting right out in the open—you might pass by any one of them. Some are obvious, like Brooklyn's Mosaic House, a colorful mural of tiles covering a brownstone. Others you have to know about to find, like the specific grate that blew air up Marilyn Monroe's dress in the famous photo. And then there are the streets that are just cool overall, like Bond Street in NoHo. That short block hosts a dozen uncommon styles of architecture as well as several notable pieces of art. Block Beautiful on East 19th Street is another one, known for its picturesque homes, each in a unique architectural style. In fact, every block in the city is its own custom combination of dynamic beauty, always changing, and you never know where you might find an unusual combination of the cool and the strange.

The Waterfall Tunnel

Behind the McGraw-Hill Building right near Times Square is a small park divided by a wall in the middle. The twenty-foot-tall wall has a gorgeous waterfall on each side. And running through the wall is a plexiglass tunnel. You can walk right through the waterfall and watch the falling waves cascade around you, without getting wet. The tunnel has been in place since 1975, and the same waterfall tunnel effect was first demonstrated at the Electrical Utilities Pavilion at the 1939 New York World's Fair. I was so happy when I came across this tunnel while hustling through Midtown during the workweek that I walked back and forth in it enough times to make me late to my meeting. Worth it.

Between West 48th and West 49th Streets,
between Sixth and Seventh Avenues,
Midtown, Manhattan

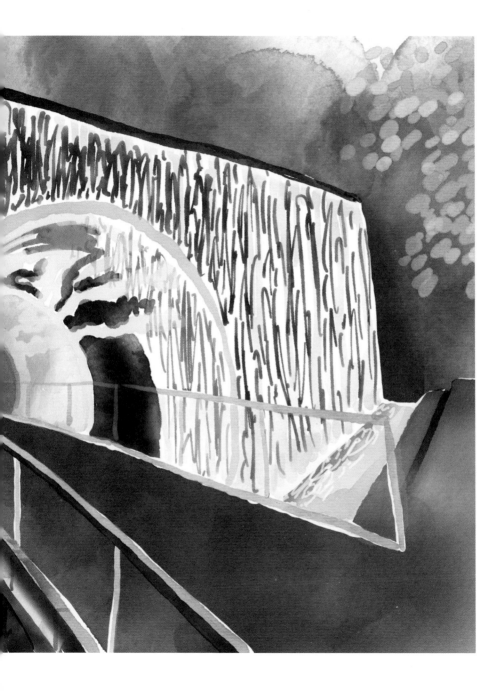

The Brooklyn Heights Promenade

The Brooklyn Bridge counts as a "known" New York site, but there is a particular vantage point of the bridge that's more obscure. The Brooklyn Heights Promenade is a wide walkway with benches, stretching along the East River high above newly renovated park piers. The Brooklyn-Queens Expressway roars underneath, and the promenade was built, in part, to keep the sound of the expressway from reaching the ritzy homes in the neighborhood. The important thing to know is that the promenade offers the most spectacular view of the NYC skyline. From here, you can see the Statue of Liberty, One World Trade Center, the whole Financial District, the Manhattan Municipal Building, the South Street Seaport with its *Goonies*-like ship, and the notoriously vile former Verizon Building. All the way on the right sits the Brooklyn Bridge, and you can even see the Chrysler Building and the Empire State Building behind it.

I do a trick whenever friends or family visit the city for the first time. When we're a block away from the tree-hidden promenade, I tell them to avert their eyes and look at the ground, and then I lead them there slowly. When they're finally standing right up against the railing, I tell them to look up. I love seeing the amazement on their faces as the panorama of New York Harbor unfurls before them.

After you walk to the north end of the promenade, there's a relatively hidden pedestrian boardwalk bridge in Squibb Park that winds down to Brooklyn Bridge Park below. The floating boardwalk makes you feel like you're walking right into the city skyline itself.

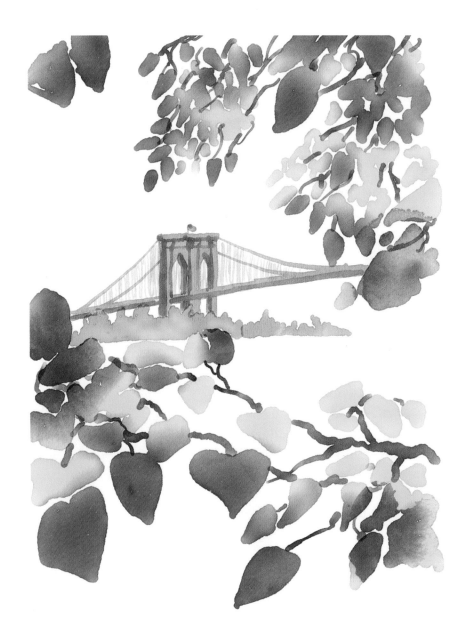

Orange Street & Columbia Heights, Brooklyn Heights, Brooklyn

The Peter Plaques

This is one of the first secrets I discovered, because it happens to be located near where I lived when I first moved to the city several decades ago. I was walking on a pretty nondescript block of 2nd Avenue, next to a playground for tennis and basketball, when I stepped on something curious. Embedded along the length of the block are large concrete plaques in vibrant colors. Each one is devoted to a Peter. Yes, every classic fictional Peter you can think of, from Peter Piper to Peter Rabbit, is represented here. There's Peter Pan, and my personal favorite, Peter Parker, whose face is split to show half his Spider-Man alter ego. Put in place during a renovation of the playground in 1998, it's a fun tribute to the two real-life Peters also included: Peter Cooper and Peter Stuyvesant.

Stuyvesant, who lived from 1610 through 1672, was the director general of New Amsterdam back when the city was a Dutch colony. He owned lots of farmland in the area and a statue of him stands in Stuyvesant Square, shown on page 60. Peter Cooper lived from 1791 through 1883 and was an inventor and philanthropist who built the first American steam locomotive, the Tom Thumb. The pair of Peters also lend their names to a large housing complex nearby, Stuyvesant Town-Peter Cooper Village.

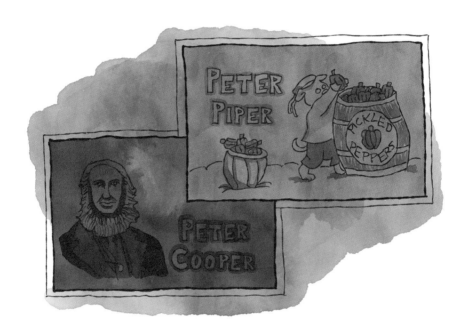

2nd Avenue between East 20th & East 21st Streets, Gramercy, Manhattan

The New York Yacht Club

This radically designed building on West 44th Street looks like any other Midtown building on the ground floor: ordinary blocks of stone. But huge windows take decisive command of the second story, led by ship's prows bursting out of them. The rest of the building is nautical-themed, too, from the concrete water pouring out of those windows, to Poseidon overlooking the entrance, to the huge anchors in the club's crests. Opened in 1901, the clubhouse was designed by the same architects who designed the exterior of Grand Central Terminal. The interior of the clubhouse isn't too shabby either: a grand "model room" features tons of ship models spread over two stories, with an ornate fireplace and a beautiful Tiffany stained glass ceiling. A dining room is designed to mimic the wooden hold of an old sailing ship. And the huge library has more than thirteen thousand volumes and manuscripts on its maritime theme. The model room is open for public tours, but only on the last Tuesday of each month, and reservations are required. Visit nyyc.org/public-tours to book a spot.

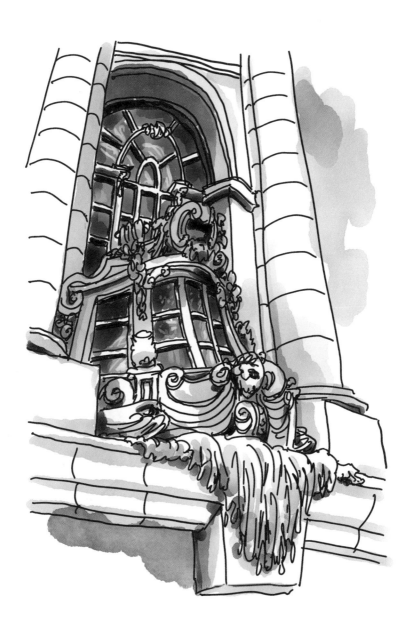

37 West 44th Street, Midtown, Manhattan

Stone Street

New York used to be relatively bereft of outdoor dining and pedestrian squares, especially compared to Europe's piazzas. A big change came in 2009, when five blocks of Broadway in Times Square were closed to traffic, creating a huge pedestrian mall. After that successful test, other areas of the city followed suit, such as the remodeling of Astor Place and the expanded Flatiron Plaza. In 2020, the COVID-19 pandemic created a huge boom in outdoor dining, with restaurants building increasingly ornate dining sheds that spilled onto the streets throughout the city. But one spot thrived as an outdoor dining spot long before that: Stone Street, in the heart of the Financial District. One of New York's oldest streets, it's marked as the Stone Street Historic District now. Open only to pedestrians, the street is covered with nostalgic cobblestones and period lighting, which complement the spirit of camaraderie and revelry at the outdoor tables of all the restaurants and bars on the street.

Stone Street, Financial District, Manhattan

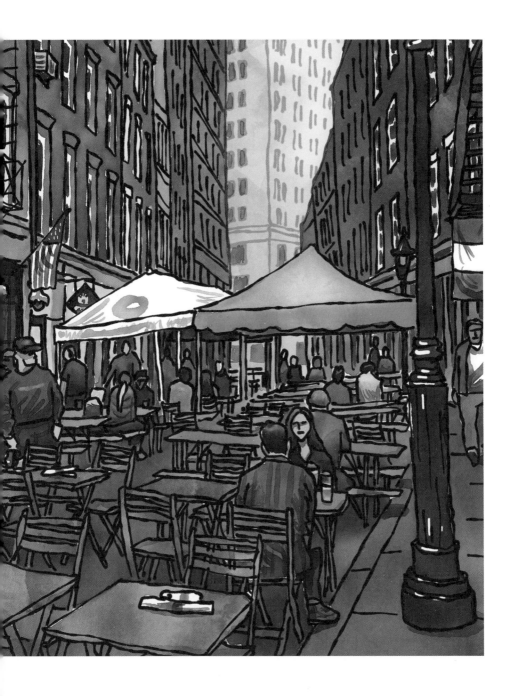

The Silk Clock

This two-foot-by-three-foot, intricately detailed clock probably sees the most traffic of any secret site in this book. Park Avenue and East 32nd Street teems with puffy-vested, blue-shirted business-doers during the day, but rarely do they look up to notice this little gem sticking out of the side of the building about ten feet up. The 1926 clock was designed by artist William Zorach, along with the world-famous architecture firm of McKim, Mead & White, and even though it's powered by an antique weight-driven pendulum, it still works today. The theme of its design is the nature of silk, as the Schwarzenbach Building it's attached to once housed a silk business. You can see silkworms and mulberry leaves on the clockfaces. The ancient Persian prophet Zoroaster sits on top, and every hour waves his wand to open a cocoon and let loose a small figure of the "Queen of Silk," holding a tulip.

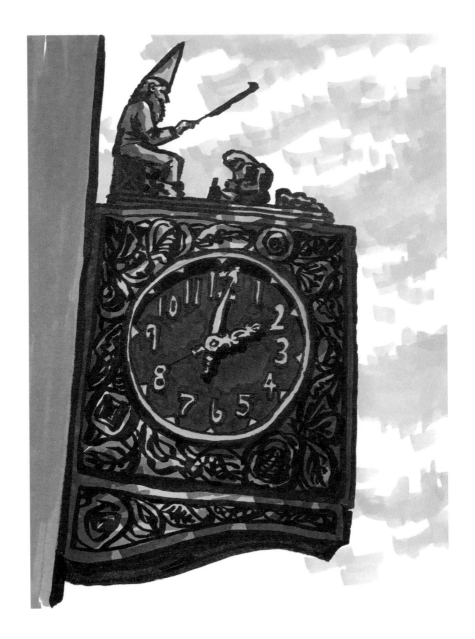

470 Park Avenue South, Midtown, Manhattan

Water Towers

Water towers are a New York City staple, but many people either don't notice them or assume they're no longer used. In fact, most water that city residents bathe in and drink still comes from rooftop water towers. They look old because they are, and also because they're made of untreated, unpainted wood—still the best material for the job. The tanks use simple gravity to create water pressure for the buildings. The city used to require that all buildings six stories or higher have a water tower, each of which can store six thousand to thirteen thousand gallons. (Buildings with fewer than six stories subsist on the natural downstream pressure of the water that flows from the mountains upstate.) There are even more towers than you'd think, because some places hide them inside a higher brick extension of the roof. There are only two companies in the city that make them, and they're both family-owned businesses more than a hundred years old. This sketch shows a layered series of water towers at West 23rd Street and 5th Avenue, across the street from the Flatiron Building.

186 5th Avenue, Flatiron District, Manhattan

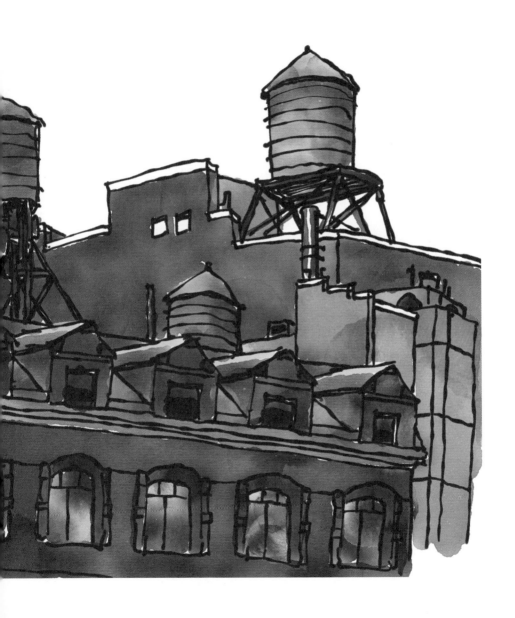

58 Joralemon Street, Brooklyn Heights, Brooklyn

Joralemon Street

If you're ever visiting Brooklyn Heights with friends, take them to Joralemon Street between Hicks Street and Columbia Place and ask them to find the thing that's wrong. It's not easy—it's disguised really well. Even without the anomaly, the picturesque street is worth a visit. The road is lined with old stone blocks instead of regular pavement. Flowers wind their way up wrought-iron railings. London plane trees spread over the sidewalk and wave their leaves in the light breeze. Brownstone stoops and fine brick detailing are the hallmark of the expensive town houses. It's one of the most charming blocks in the whole city.

But see that house in the center of the drawing? It's just a little bit off. The windows are much darker than its neighbors'—they've been completely blacked out. The door has no window of its own, unlike the doors of all the other houses on the street. And there's a weird metal cover slanted over the front of the building. This is all because this house isn't a house at all. It's secretly a ventilation shaft for the 4 and 5 subway lines—and has been since 1907. For decades, smelly exhaust poured from the windows, until renovations in the 1990s shunted the ventilation to the roof and better disguised the building to match the street. It can also be used as an entrance for MTA employees, and as an emergency exit from the subway. It's admirable that such a potentially utilitarian structure was made to blend in so seamlessly with the serenity of this street.

The Harriet Tubman Memorial

This memorial by Alison Saar, titled *Swing Low*, is a bronze statue honoring the famous Underground Railroad savior. Placed at West 122nd Street in Harlem in 2007, it features many symbolic details, like the "roots of slavery" being pulled up behind her, the faces of formerly enslaved people (it's estimated she saved seventy) in her skirt, and surrounding plants native to her home state of Maryland. Saar chose to depict Tubman as "a train itself, an unstoppable locomotive" and you can see the train's cowcatcher design at the front of Tubman's feet, plowing the way forward into freedom.

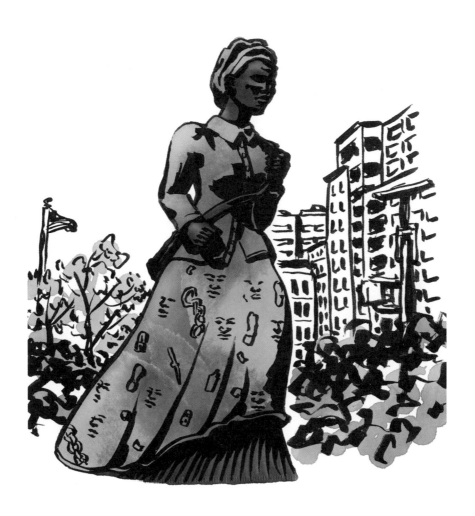

Intersection of West 122nd Street, St. Nicholas Avenue &
Frederick Douglass Boulevard, Harlem, Manhattan

The Mosaic House

Boerum Hill in Brooklyn has a traditional small-town feel, with just two main streets of shops tucked into three-story buildings, surrounded by quiet, tree-lined residential streets. But one narrow home on one of those streets is very different from the rest. The top two floors are painted a deep pumpkin color with dark-green trim. It's pretty. But the ground floor is something else.

The Mosaic House is the creation of Susan Gardner, who began attaching things to her house back in 2001 as a form of neighborhood therapy after the attacks of September 11. The art teacher started off with a small flower and kept adding items. Many of her neighbors have brought things to add as well. Now the house is covered with millions of tiles, beads, rocks, shells, baubles, and buttons. The tiles form bursting flowers and dancing figures, shown here. Little pieces of mirrors reflect the neighbors' trees. Even the low fence around the home is covered in beads and color. There's a giraffe statue and a colorful human head made of rubber. On top of it all, and covering the windows, are a dozen signs promoting social justice.

The tiles have started climbing up and encroaching on the second floor as well. As Gardner told the *Wall Street Journal* in 2016, "I recommend to everyone to start gluing things to houses. It's very therapeutic."

108 Wyckoff Street, Boerum Hill, Brooklyn

A Green Tunnel

East 26th Street between 2nd and 3rd Avenues seems like a perfectly ordinary side street, though it does have a liquor-infused ice cream "barlour" called Tipsy Scoop, and Holographic Studios, which makes hologram gifts, has a gallery, and touts itself as a "very good hidden secret of NYC!" But the bulk of the block is plain and unremarkable five-story apartment buildings. One large doorway, however, looks dark. When you look in, an old-looking tunnel comes into view, and the darkness dissolves into green. The long tunnel is covered with vines and leaves—all fake—decorating its walls and ceiling, with white holiday lights strewn throughout. At the end is a shadowy gate.

Sometimes the tunnel is locked, but at other times it's been open. It leads into the pleasant courtyard of a perfectly normal residential building—but imagine the fun of living there and experiencing this dramatic entrance each time you walk home with your groceries!

212 East 26th Street, Kips Bay, Manhattan

Block Beautiful

East 19th Street between 3rd Avenue and Irving Place earned the label Block Beautiful in the early 1900s after architect Frederick Sterner remodeled some of its homes. This act popularized the very concept of remodeling, which wasn't practiced much at that time, since there had been seemingly unlimited empty land for new structures. The street deserves its nickname, with each home a unique creative surprise—from the ivy-covered building on the corner of East 19th Street and Irving, to the small carriage house across the street that used to be an Italian car showroom, to the two jockey hitching posts that marked the home of sportscaster Edward Britt "Ted" Husing. The street has attracted a lot of creative types over the years, including fashion designer Oleg Cassini, whose building's stained glass windows evoke Tudor Revival architecture; cofounder of the New York City Ballet Lincoln Kirstein, who lived in a low red building with unique wavy ironwork; and famed realist painter George Bellows, whose former home is now decked out in overlapping layers of flower boxes. One of my favorite buildings has detailed giraffe-themed tile work. This was created by painter Robert Winthrop Chanler, who shaped his home into what he called a "House of Fantasy" filled with his own works. At the other end of the block, behind the spider-laced metalwork of one round window, sits a real taxidermied monkey, snarling at passersby.

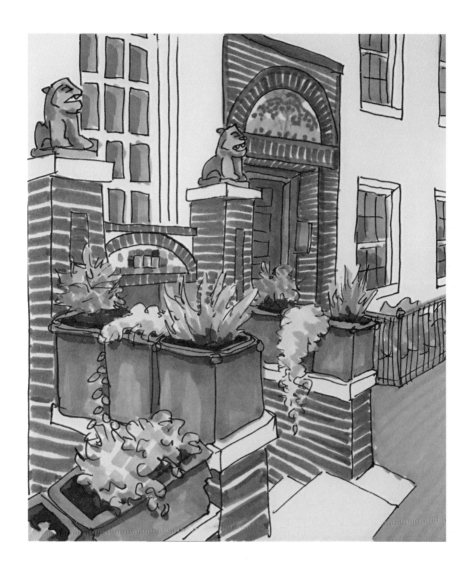

East 19th Street between 3rd Avenue & Irving Place, Gramercy, Manhattan

A Haunted House

See what turns your head first as you walk by this seemingly normal row house on East 18th Street between 1st and 2nd Avenues in the Gramercy neighborhood. It might be the slithery lizard crawling up the wall. Or the life-size head half-sticking out of a bench. Maybe the giant phantom phasing through the stones. Or the dragon, the screaming faces, or the witches. This three-story house, built in 1901, appears infested with terrifying protruding demons, not to mention a row of the seven deadly sins. These could just be your above-average haunted October decorations . . . except that this house is decorated year-round.

The macabre home is the brainchild of Joel Krupnik and Mildred Castellanos, whose names adorn the front wall on a golden plaque. Krupnik passed away in 2019, but he left behind a legacy not just of Halloween decorations but of Christmas ones as well. In 2005, the house decorations were expanded to include a bloody Santa holding a dismembered doll's head. It was intended as a protest against the commercialization of the holiday, but the neighbors were not amused, with one man eventually tearing the whole display down. Since then, the house has stuck to its regular, scary-but-less-offensive decorations.

318 East 18th Street, Gramercy, Manhattan

Freeman Alley

Believe it or not, Manhattan is almost devoid of alleys. When the city's famous grid was planned in 1811, it didn't include them. That's why garbage has to be left on the main streets for pickup, which tourists never fail to notice. So all those alleys you've seen in TV and movies have usually been filmed on sets in LA. But Freeman Alley is authentic and open to the public, though you haven't seen this one in the movies before. Maybe that's because it's too amazing to seem realistic. When you find and turn in to this hidden alley, tucked next to a building materials warehouse, it feels like you're walking into a collage. The burst of color on the walls—hundreds of posters and stickers and flyers and pieces of graffiti—stands out even more against the conventional bland dampness of the concrete alley floor. The last piece that makes the alley feel special is the string of hanging lights at the end, framing a hidden trendy restaurant called Freemans.

Next to 10 Rivington Street,
Lower East Side, Manhattan

The Pink House

Hovering over a nondescript deli on 4th Street and Avenue B is a striking combination of lilac walls trimmed in rich magenta, ocean blue, and shiny gold. The apartment house has been decked out in unique colors for a long time, and it's all the brainchild of the owner, Antonio "Tony" Echeverri, a Colombia native who came to New York in the 1970s.

Echeverri saved up for nearly two decades in order to purchase the building in 1992, and had to do extensive work to rehabilitate it. It's covered with his handmade touches and details, such as tiny sculptures. "It gives me joy to see that people come by to admire the building," Echeverri told the *Village Voice* in 2016. He repaints the building every five years with paint he mixes himself.

"In my homeland, all of the houses are painted different colors, and they constantly attract and distract your vision," Echeverri explained. "That's what I wanted to do."

246 East 4th Street, East Village, Manhattan

Delancey Street Subway Station

There is a particularly vivid example of the amazing art found throughout the New York City subway system in the Delancey Street/Essex Street station serving the F, J, M, and Z lines. In the 2004 tile artwork called *Shad Crossing* by Ming Fay, the bigger part of it, showing two more fish, is on the upper mezzanine, along with a huge mural of an orchard by the same artist. As with a lot of tile artwork that aims for realism on a large scale (pun intended), up close you can see the blending of hundreds of subtle color differences. The greatest ingenuity of these is the use of the shiniest tiles to augment the reflective nature of fish scales.

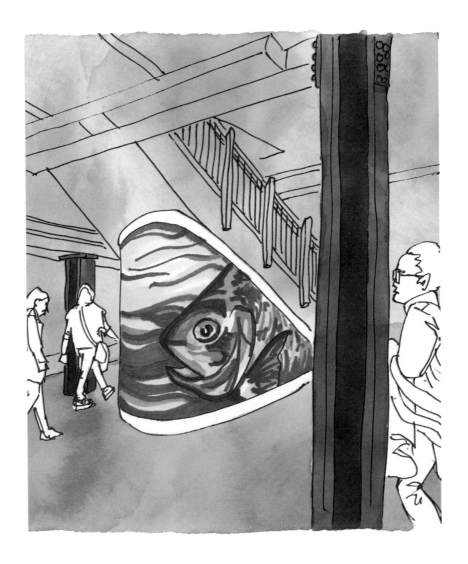

Delancey Street & Essex Street, Lower East Side, Manhattan

6½ Avenue

Where can you find 6½ Avenue? Why, between 6th and 7th Avenues, of course. I swear this is real, and the first time I stumbled onto it it blew my mind (like the elevator stopping halfway between floors in the film *Being John Malkovich*). The avenue was created in 2012 to connect what was a series of existing parks and courtyards into a coherent strip—201 years after Manhattan's other avenues were laid out. It's a charming walkway that runs between West 51st and 57th Streets, and a convenient shortcut in Midtown. There are even a few buildings you can stroll through as part of the avenue.

The spaces that make up the avenue are known as POPS—privately owned public spaces. The city gives incentives to property developers if their buildings' footprints include public spaces: atriums, parks, benches, open spots. There are more than five hundred POPS in the city, and they provide essential respites on streets where buildings would otherwise blend together with no breaks. It's another sign that New York is truly made for pedestrians.

From West 51st Street to West 57th Street between 6th Avenue & 7th Avenue,
Midtown, Manhattan

Elevated Subway Stations

The New York City subway system has 472 stations, and many are elevated. However, the one shown here, at West 125th Street, is the only remaining elevated station in Manhattan—and an impressive one at that. It was one of the original twenty-eight stations opened in 1904, and the gorgeous steel structure supporting it is known as the Manhattan Valley Viaduct, a long bridge of arches designed to keep trains level, and a designated landmark. Most of the elevated lines followed the street plans in Manhattan, and as such they blocked the light and became seen as a blight on the city. By the middle of the twentieth century, all the other elevated stations in Manhattan had been torn down and replaced by underground trains.

Another notable surviving elevated station sits over the Gowanus Canal at Smith and 9th Streets in Brooklyn. At 87½ feet above ground level, it is the highest rapid transit station in the world, and has a wonderful view of the Manhattan skyline.

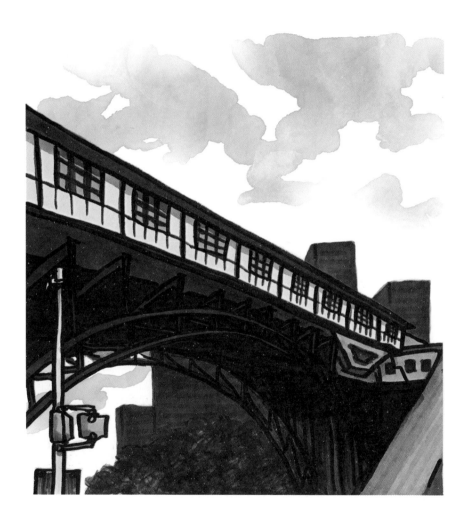

West 125th Street & Broadway, West Harlem, Manhattan

Bushwick Street Art

The center of Bushwick in Brooklyn is known for its street art, but there's an even better spot just to the north, in what can be considered either Bushwick or East Williamsburg. There, the intersection of Meserole and Waterbury Streets, is the epicenter of a street art explosion. The neighborhood is undergoing gentrification, with some restaurants and shops popping up, but as of this printing, it is still mostly warehouses with little foot traffic. Some of the desolate streets look almost postapocalyptic. But as you approach the center, you'll see that more and more of the walls are covered with dramatic and detailed art—mutant animals, cartoon people, political manifestos, stylized names, and fifteen-foot-tall portraits, like this one. The artwork stretches throughout the entire industrial district. It's partially due to the encouragement of the Bushwick Collective, an arts organization fostering local and international artists, to blanket the area with street art. If you visit, make sure you take some photos, because the next time you're there, the art will have changed.

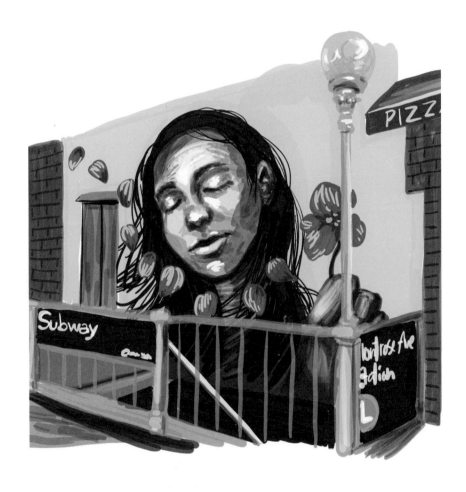

Meserole Street & Waterbury Street, Bushwick/East Williamsburg, Brooklyn

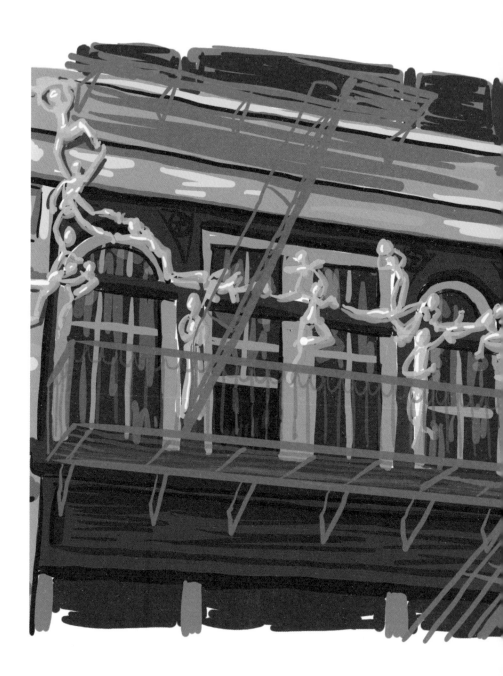

Bond Street

Tucked away in NoHo is a small cobblestoned street with some of the craziest architecture you'll ever see. What catches the eye is the startling juxtaposition— from a landmarked traditional New York apartment building with ornate window frames and cornices at 35 Bond, to a flat rusted steel structure at 22 Bond, to a tower of weird green tubes at 40 Bond, to a building whose face is covered in plants at 41 Bond.

One historic 1893 building at 24 Bond holds the award for standout decor: golden statues dancing up its windows and fire escape. This building has quite the artistic pedigree. It houses the Gene Frankel Theatre, founded in 1949. It was also the jazz musician Sam Rivers's Studio Rivbea loft in the 1970s. The legendary photographer Robert Mapplethorpe used it as his studio in the 1980s. And the painter Virginia Admiral—the mother of actor Robert De Niro—was a former owner. As of this writing, sculptor Bruce Williams has lived here with his wife for decades; he created the glowing acrobatic revelers, adding to them over time. I got to meet Bruce when he came out to visit my drawing group as we were sketching the street.

Bond Street also has one more big tie to the art world—20 Bond was the studio of famed artist Chuck Close, whose work adorns the 86th Street and 2nd Avenue subway station.

24 Bond Street, NoHo, Manhattan

A Famous Subway Grate

There's nothing obviously striking about the southwest corner of Lexington and East 52nd Street—until you look down, and unless you're in the know. Maybe you'd get a hint if you happened to be wearing a dress as you walked over it. This unassuming grate in front of a restaurant marks the spot where Marilyn Monroe famously stood in the movie *The Seven Year Itch*, the skirt of her dress flying from the wind gusting up from the passing subway below.

Well, except that she didn't stand here . . . not in the movie, at least. The shots were unusable due to the roar of both the subway and the crowd, so the version that appears in the movie was filmed on a soundstage re-creating the scene. But because the original New York filming event had been leaked to the press, it had the desired effect of attracting thousands of spectators. The outtakes from that scene are some of the defining images of the twentieth century.

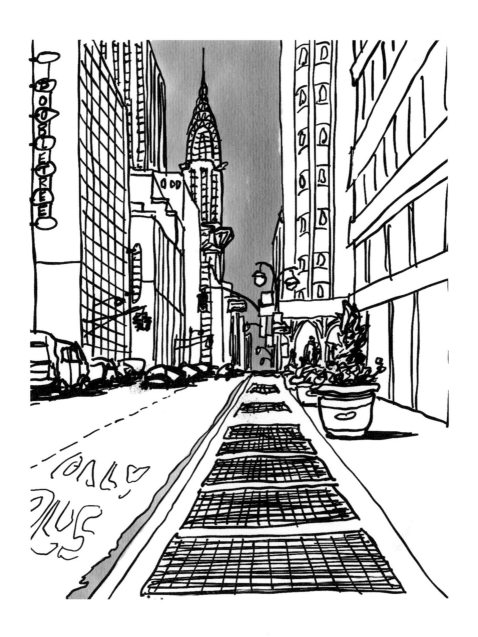

East 52nd Street & Lexington Avenue, Midtown, Manhattan

SHOPPING SPREE

You can buy anything in New York—at any time of day.
Do you need a pair of secret identity glasses or a glowing ring to make
you a superhero? How about a classic candy from your childhood that's
no longer sold in the grocery store? Or spices from any country in the
world? The shops in this chapter either sell something spectacular or
have an incredible feature, like a giant snake made out of books or an
elaborately painted solar system on the ceiling.

New York's clustered and themed neighborhoods extend to
commercial enterprises as well, like the glut of florists at 6th Avenue
and West 28th Street in Chelsea, the chic designer fashion boutiques
huddled together on Prince and Greene Streets in SoHo, and the long
string of lighting and industrial restaurant supply shops found on the
Bowery. But the locations in this chapter are scattered all over, off the
beaten path. Happy shopping!

Albertine

A bookstore named after a character in a novel by Marcel Proust, Albertine carries books in French, and French books translated into English—the largest collection of such books in the United States. Its top floor features this stellar ceiling, painted with stars, constellations, and the symbols of the planets and zodiac. Albertine is located on 5th Avenue, across from Central Park, in the landmarked Payne Whitney House designed by legendary architect Stanford White. The rest of the building is home to the Cultural Services of the French Embassy, which sponsors the bookstore.

972 5th Avenue,
Upper East Side, Manhattan

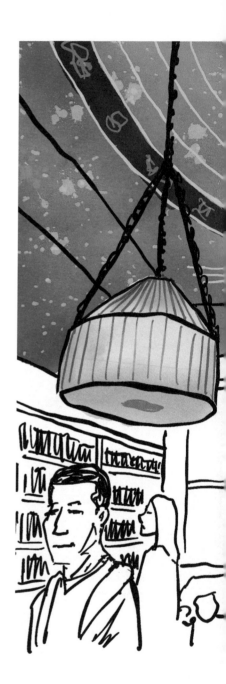

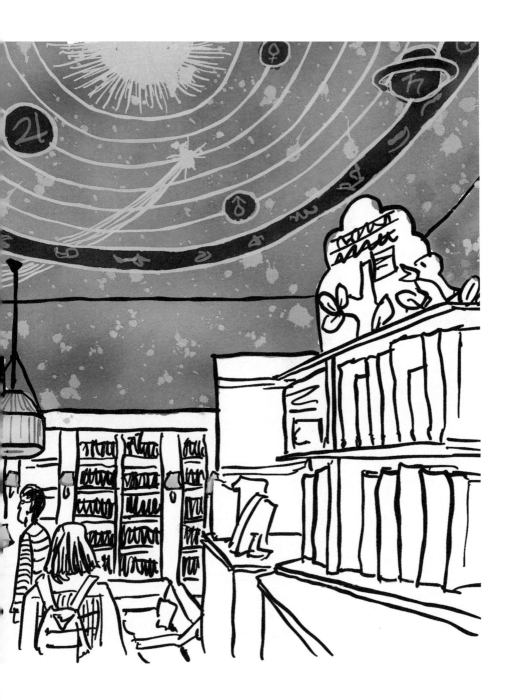

The Brooklyn Superhero Supply Co.

Glowing energy rings. Cans of omnipotence. Sidekick utility belts. Secret identity glasses. Billowy capes of every size and color. Chemistry kits and instructions for building robotic arms. If you were a budding superhero, where would you buy all of the critical supplies you need to punch crime in the face every night? The Brooklyn Superhero Supply Co., of course!

Is this place for real? Sure, and turns out it's two great places for kids in one. Not only can you buy superhero supplies in the front, but those novelty toys and gimmicks also help fund the secret hideout accessible behind a bookcase: a nonprofit youth writing center, 826NYC. The organization, founded by novelist Dave Eggers and educator Ninive Calegari, is dedicated to helping students ages six through eighteen with their writing skills. The bookcase holds what are certainly the best items offered for sale: books containing collections of the kids' writings.

So stop by the next time you need a grappling hook or a gallon of antimatter. (Just don't tell your supervillains about it.)

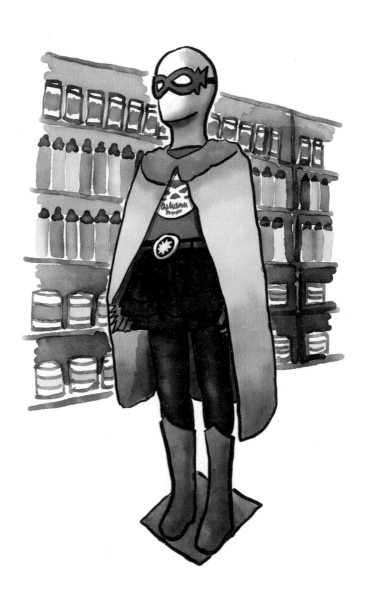

372 5th Avenue, Park Slope, Brooklyn

The Old Print Shop

The Old Print Shop is an art gallery filled to the brim with prints of American art of all shapes and sizes, just as it has been for 125 years. It's changed locations a few times since it was founded in 1898, including in 2022. But having been to both the previous location and the new one, I can hardly tell the difference. With its wooden floors, walls hung with art, and huge enclosed cabinet tables that hold browsable stacks of hundreds of prints, the large space reminds me of my printmaking studio room from college.

For the first thirty years, the shop was run by its founder, Edward Gottschalk, who created it in 1898. Then Harry Shaw Newman, who had sold prints to Gottschalk, bought the shop, and it's stayed within the Newman family ever since. My favorite thing about the shop is that many of the prints feature New York City as their subject matter. In particular, the 1930s street scenes by Martin Lewis always catch my eye. There are also classic historical scenes, portraits of the nineteenth-century well-to-do, contemporary abstract art, and many glorious antique maps, as shown here.

49 West 24th Street, 2nd Floor,
Flatiron District, Manhattan

Kalustyan's

We used to have a half-joking tradition in my family called Plunging Lentil Tuesdays, when we'd set out an enormous bowl of raw lentils into which our toddler would gleefully dunk her hands, over and over. She'd sift the lentils softly as if they were sand and watch them pour through her fingers. Good thing she was never let loose in Kalustyan's. Imagine thousands of bowls of lentils—and spices, and rice, and beans and nuts and dried fruits—scooped up into little bags that softly rattle and squoosh soothingly when you squeeze them. Each bag is labeled and lined up meticulously on hundreds of wire shelves. Kalustyan's originally featured Turkish and Armenian spices when it was founded in 1944, and then expanded to offer a lot of Indian spices as the neighborhood morphed in the 1960s and '70s into "Curry Hill" (a play on the adjoining Murray Hill). Now it offers ingredients from around the world, like Madagascar bourbon vanilla extract, Ethiopian wild thyme, and New Zealand manuka honey.

The nondescript building was also the host of an unusual event, which is commemorated on a nearly hidden plaque outside the entrance. It was US vice president Chester A. Arthur's home, where, in 1881, he was inaugurated as president when James Garfield was shot just four months after taking office.

123 Lexington Avenue, Kips Bay, Manhattan

The Drama Book Shop

Founded more than a hundred years ago, the Drama Book Shop is a Theatre District institution. It's even received its own Tony Award, 2011's Honor for Excellence in the Theatre. (Which brings to mind an entire store singing and dancing onstage, but I guess the acceptance criteria must be different from what I imagine.)

Their current location opened in 2020, under new ownership that now includes Lin-Manuel Miranda—which is obvious from the sheer quantity of *Hamilton* and *In the Heights* merchandise on display. It's a big store with a café and many rows of how-to-act books, monologues, sheet music, and plays. Winding throughout the entirety of the store is the real showstopper: a mind-bending snake made of hundreds of books glued together. The whole space was designed by *Hamilton* scenic designer David Korins and his team.

266 West 39th Street, Midtown, Manhattan

Zoltar Speaks

"I wish I were big," says the child version of the character played by Tom Hanks to the ominous fortunetelling machine in the movie *Big*, as it whirls, opens its mouth, and stares with its glowing red eyes. That machine is Zoltar Speaks, and one of them also happened to sit at the corner of St. Mark's Place and 2nd Avenue in the East Village for many years. Sadly, the moderately famous bodega hosting it, Gem Spa, closed during 2020's pandemic, like so many New York stores and restaurants. But Zoltar hung on to life and ended up at OMG Pizza in Bushwick, Brooklyn, next to some giant pizza wall art and a stuffed animal-grabbing claw machine.

Fortunetelling machines have been around in the United States since 1904, and Zoltan (probably derived from the word *sultan*) first appeared in 1965, with Zoltar popping up shortly thereafter. Today, animatronic Zoltars are manufactured by Olaf Stanton and his company, Characters Unlimited. The company makes all sorts of life-size human replicas, as well as games and attractions, and you can even order a custom figure of yourself or a loved one. Perhaps the weirdest part of each Zoltar is its lifelike teeth—made from a cast of Olaf Stanton's own.

What would you ask of Zoltar?

1307 Myrtle Avenue, Bushwick, Brooklyn

Jeweled Gardens

Two floral shops have saved my life more than once when I've needed a standout gift for someone. Crystals Garden and the East Village Florist sit right next to each other on East 10th Street and merge into a single—and singular—experience. Far more exotic and bizarre than ordinary floral shops, they contain not just a lot of flowers but also thousands of plants and arrangements delicately placed into every nook and cranny of the barely walkable tight spaces, which spill out onto the sidewalk as well. There are dozens of terrariums hanging from the ceiling, ranging in size from billiard balls to watermelons. There are also little stone garden decorations, crystals, Buddha statues, jewelry, tiny waterfalls, and bonsai trees. The craftsmanship is exemplary, and it's reflected in the prices. If you've always wanted to let loose a bull in a china shop, this would be the place to do it.

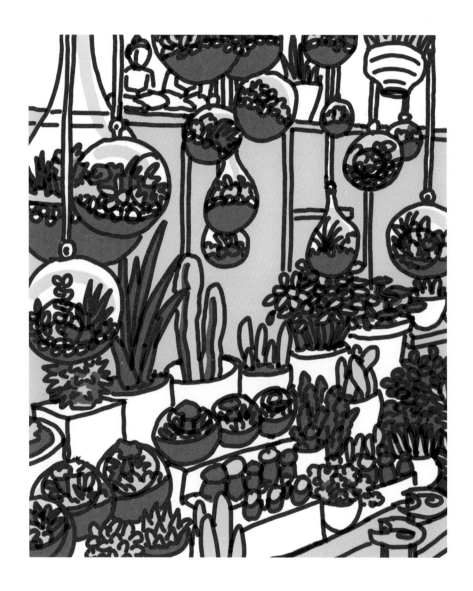

247 East 10th Street, East Village, Manhattan

Kinokuniya

Though Kinokuniya is one of the nicer bookstores in the city, its first floor is perfectly ordinary. But the other floors are unlike anything you'd expect. The vast basement features books and magazines in Japanese, and a hodgepodge of greeting cards, housewares, and more. The second floor is somewhat hidden, accessible only via an escalator tucked away in the back. As you ride up, you pass a doll collection mounted on the wall and then a stern and startling giant anime face, painted on the wall at the top.

It turns out that this floor is dedicated to manga, anime, comic books, art books, and toys. (Although many adults buying the toys would refer to them as "collectibles.") There's a whole table dedicated to Studio Ghibli's magnificent films, for example, from puzzles and bookmarks to plush Totoros. To top it off, there's a tiny café peacefully overlooking the green stretch of Bryant Park below, and serving light Japanese rice bowls, bento boxes, and pastries. As a big fan of manga and comics, I was thrilled when I discovered this floor.

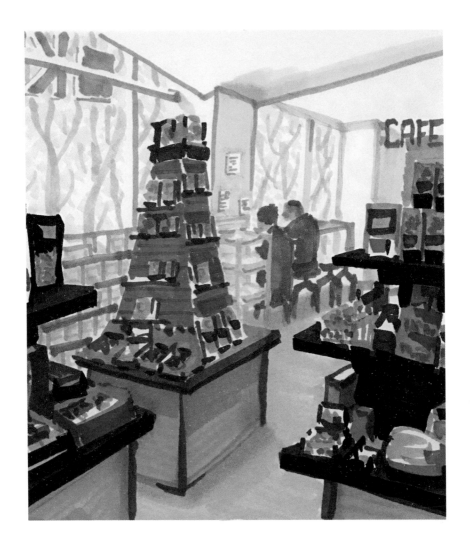

1073 6th Avenue, Midtown, Manhattan

Economy Candy

Imagine if at the end of touring Willy Wonka's factory you arrived at a small gift shop filled to bursting with every kind of candy. That's the feeling you get in Economy Candy. Overflowing buckets of gummy worms crowd out dispensers of rainbow jelly beans, and giant twirled lollipops stand in rows at attention. There is barely any room to walk. This jam-packed store on the Lower East Side started as a tiny pushcart during the Great Depression, and has been family-run ever since. Some of the retro candies it sells, like Charleston Chews, Sugar Daddies, and Mary Janes, seem almost as old as the business itself. (You can search candy by decade—or color—on the store's website, economycandy .com.) Every treat your grandparents ever struggled to chew as kids can be found here, alongside all the modern varieties you can name—two thousand different types of candy for sale.

At more than eighty-five years old, Economy Candy is New York's oldest candy shop.

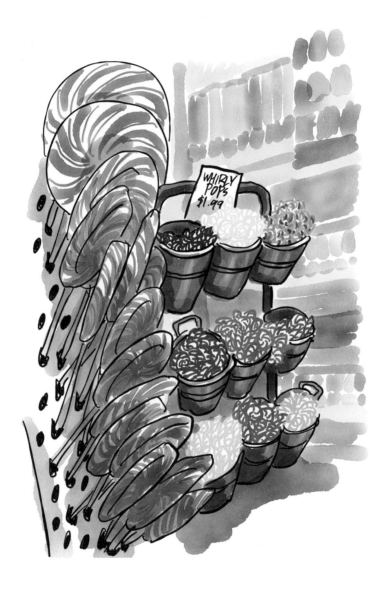

108 Rivington Street, Lower East Side, Manhattan

Chartwell Booksellers

Let's say one day you happen to find a cozy bookstore with a plush red carpet, hidden inside an office building off Park Avenue in Midtown. You browse a bit and notice some books about Winston Churchill. "Oh," you think, "I must be in the biography or history section." So you move to another part of the store, only to see more books on Winston Churchill. As you try to keep browsing, you start to look around frantically, only to slowly realize that every . . . single . . . book . . . is about Winston Churchill. It's like the world's mildest *Twilight Zone* episode, or just Chartwell Booksellers, "the world's only Winston Churchill bookshop."

What's also strange is that it didn't start out that way. Barry Singer founded the bookshop in 1983, and as he recounted on *CBS Sunday Morning*, he found that the bankers and corporate raiders working in the skyscraper kept asking for books on Churchill. He learned that Churchill had written more than forty books himself, and that these, as well as biographies of him, were in great demand. And so he found his niche. The store has since been frequented by political figures including former US secretary of state Henry Kissinger and Caspar Weinberger, President Reagan's secretary of defense, as well as by Churchill's grandchildren.

55 East 52nd Street, in the lobby of the Park Avenue Plaza Building,
Midtown, Manhattan

Bowne & Co., Stationers

The South Street Seaport historic district's cobblestoned streets and dusty brick buildings immediately evoke the eighteenth century. And right outside the door of Bowne & Co., Stationers, there are a couple of huge ship anchors sitting among a row of big metal boat cleats (the posts you tie a ship's rope to on the dock). The same spirit of antique black metal and traditional craftsmanship carries through into the shop, an institution dedicated to keeping hand printing techniques alive. Part of the South Street Seaport Museum, the print shop was formed through a partnership with Bowne & Co., the oldest operating business in New York—started in 1775. The store offers cards and posters and pamphlets and paper, all printed in small batches and often featuring unusual subjects, like greeting cards with abstract shapes and nineteenth-century clip art, and posters of stories made from rebuses. But the highlight of a visit is getting to see the still-in-use printing presses themselves—original black iron machines from past centuries, with their matching metal plates and lead letter slugs, like the one shown here.

211 Water Street, South Street Seaport, Manhattan

QUIET
REALMS

Times Square. Taxis honking. Sidewalks packed, with commuters urging you to get out of the way. Street vendors, subway buskers, and religious proselytizers all screaming for your attention. New York isn't known for being a soft-spoken place. So I was surprised to see, as I was organizing the locations featured in this book, that a lot were very quiet, meditative spots. I should have known better: New York is nothing if not diverse, and it contains multitudes.

Some of the quiet spots are museums, ranging from the towering shelves in the Morgan Library to the stone circles in the Noguchi Museum. Others are whole tucked-away neighborhoods, like Tudor City, in which a hush envelops several blocks. Perhaps the most interesting and meditative spot in the city is *The New York Earth Room*, a giant art installation consisting of a huge space filled with dirt. It's been luring visitors to SoHo for nearly fifty years. So if you're caught up in the New York state of mind and start to feel overwhelmed, consult this list and find a spot to take a deep, long breath.

The Morgan Library & Museum

This private library, now a public museum, has to be seen to be believed. Think of the library in *Beauty and the Beast* or at Hogwarts and you'll have some idea of how impressive three stories of wall-to-wall books can be. Then let's drop in some gorgeously ornate Sistine Chapel–like ceiling frescoes while we're at it. J. P. Morgan Sr. was the richest man in the world when he had this library and the adjoining mansion built between 1902 and 1906. The side rooms contain more books and a secret vault for the tomes that require more protection than just glass cases. There's even an original Gutenberg Bible from 1454 on display.

The museum is a complex of attached buildings expanded from the original mansion and library. There's a relaxing café in a sun-drenched atrium, and rotating exhibits on several floors. There's also a second, fancier restaurant and a standout bookshop.

225 Madison Avenue, Murray Hill, Manhattan

The 2nd Avenue Subway

Excelsior! Comic-book great Stan Lee made this exclamation popular by using it to sign off his monthly Marvel letter columns, but it's also the state motto of New York, and it's carved into one of the walls of the 2nd Avenue subway. The sign is probably the loudest thing in the station. You wouldn't normally think of subway stations as quiet spaces, but these three newest ones, opened in 2017 and serving the Q line, are so vast and relatively underused (for Manhattan) that they qualify. They have the feel of a museum, and for good reason: dazzling tile art. Perhaps most impressive are the twelve huge portraits by world-famous American artist Chuck Close lining the 86th Street station's mezzanine. They embody a range of styles from throughout his career, from photorealistic to abstracted circles, but each focuses on a ten-foot-high, realistic single face. This pointillist iPad sketch attempts to capture the feeling of staring at the shiny tiles up close, here in a portrait of abstract artist Sienna Shields. It's the portrait I'm most partial to, not just for the sheer beauty of the tile work, but because she shares a first name with my daughter.

East 86th Street & Second Avenue, Upper East Side, Manhattan

Isidor and Ida Straus Memorial

Isidor and Ida Straus were two of the approximately 1,500 passengers and crew who died in the RMS *Titanic* disaster in 1912. The husband and wife had been well-known philanthropists who lived near the intersection where this statue resides. Isidor, in addition to being a congressman and a proponent of education and civil service reform, was notable for taking over the Macy's company with his brother Nathan and opening its grand store in Herald Square in 1902.

An eyewitness account from a *Titanic* survivor noted that Ida refused to get into a lifeboat without Isidor after the ship hit the iceberg. She gave her fur coat to her maid and insisted she get into the lifeboat, staying arm in arm with her husband. They were briefly depicted in the 1997 film *Titanic*.

Almost immediately after Isidor's and Ida's deaths, the city designated Straus Park and raised money from the public for this monument, sculpted by Augustus Lukeman. The reclining bronze figure is an allegory for Memory—a fitting sentiment. The Biblical quotation behind the bronze statue reads, "Lovely and pleasant were they in their lives / And in their death they were not divided."

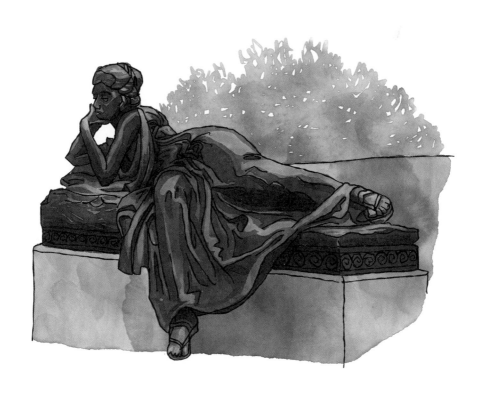

West 106th Street & Broadway, Upper West Side, Manhattan

The New York Earth Room

As you climb the stairs in this seemingly normal SoHo building, it's your ears that first notice something's different. The quiet is all-consuming, akin to that in regular art galleries but softer still. Next, your nose perks up. There's a beautiful, deep smell, one that's rarely found so strongly in Manhattan. And that's the whole point.

On the one hand, *The New York Earth Room* is just a big room filled with dirt. On the other, it's a rich, unique experience that has to be seen to be appreciated. The dirt is startlingly clean, or rather, perfectly dirty— there are no contaminants, no plants, no pebbles, no twigs. This would make it odd even if it weren't in the middle of a room. No photos are allowed, which adds to the air of a quasi-sacred ritual.

The installation is the brainchild of minimalist artist Walter De Maria. Probably the most surprising thing about it is that it's stood in place, unchanged in any significant way, since 1977. (The earth is periodically cleaned and replaced.) The room, guarded by a single relaxed attendant and with very few visitors, can only be looked at—no walking in the dirt, no playing. Just inhaling, seeing, admiring, appreciating.

A few blocks away sits another of De Maria's giant works, *The Broken Kilometer*, from 1979. It fills a huge space with a series of golden rods laid on the floor. This and *The New York Earth Room* are free to the public and are some of the most expensive works of art to maintain in New York.

141 Wooster Street, SoHo, Manhattan

The Nicholas Roerich Museum

The Russian painter Nicholas Roerich lived from 1874 through 1947 and dabbled in all sorts of things, from occultism and mysticism, to proposing his own New York skyscraper, to brokering international peace agreements, to creating a pact to protect the world's art from war. He even attempted to find and form his own country in Central Asia. That didn't work out, but his art is a different story. It is said to have "hypnotic expression." And you can see why. Gazing into one of his colorful, serene paintings of the misty Himalayas can nearly put you into a meditative state. Roerich's symbolic works embody nature and spirituality fusing together, showing glistening caves, sparkling comets, sitting gurus, and lost cities in mountains. The admission is free to see the more than one hundred paintings housed in a lovely old brownstone on the Upper West Side. It sits patiently waiting for current and future generations to discover its mystical secrets.

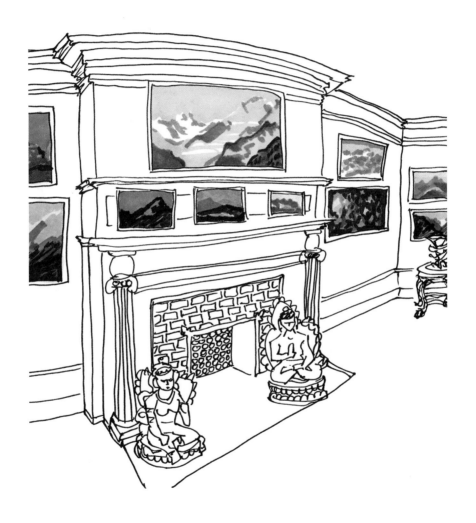

319 West 107th Street, Upper West Side, Manhattan

The Elevated Acre

In Downtown Manhattan, where the streets crisscross and close in on one another underneath the looming skyscrapers of the Financial District, green space is at a premium. But if you're someone who likes to break the rules and has a good nose for some casual trespassing, you might stumble on an oasis called the Elevated Acre. This plateau of a park looks and feels dangerously like private property—but isn't. You can get to it only by taking a barely labeled outdoor escalator at 55 Water Street, up to a landing that leads behind the office building. You end up on a small roof split into two parts. One side is boardwalked elegantly with Brazilian hardwood and tall grasses and flowers, and the other is an expanse of green turf for picnicking or sunbathing. The Elevated Acre's benches are positioned to peer over the FDR Drive and across the East River into Brooklyn, and the natural tranquil joy of the spot is heightened by its seeming illicitness.

55 Water Street, Financial District, Manhattan

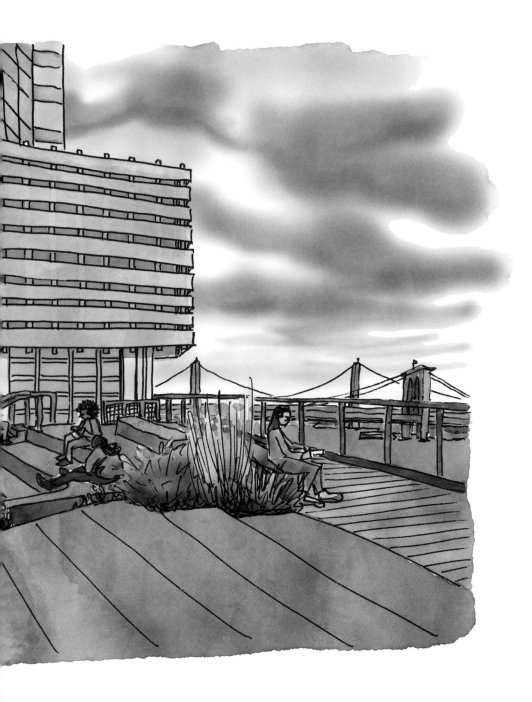

Tudor City

Could Henry VIII and sixteenth-century England be transplanted to
New York? Well, there's a neighborhood up on a hill where all the buildings
look like castles. Tudor City isn't named for the Tudors specifically, but
for its distinctive Tudor Revival architecture, which technically is closer
to neo-Gothic. The tranquility and charm of this small neighborhood,
a quiet handful of streets elevated on a sloped plateau, is accentuated
by the fact that it's right in Midtown Manhattan, a few blocks from one
of the most cyclonic spots on earth, Grand Central Terminal. Tudor
City was originally designed to be a middle-class neighborhood, and
its construction in 1926 made it the first residential skyscraper complex
in the world. It has a calm, shade-filled park and a bridge that looks
directly over the UN building, bustling 42nd Street, and the Chrysler
Building. The center of the bridge is the best spot to take a photo during
Manhattanhenge, the twice-yearly solstice alignment of the sun with
the city's streets, which creates spectacular sunset views.

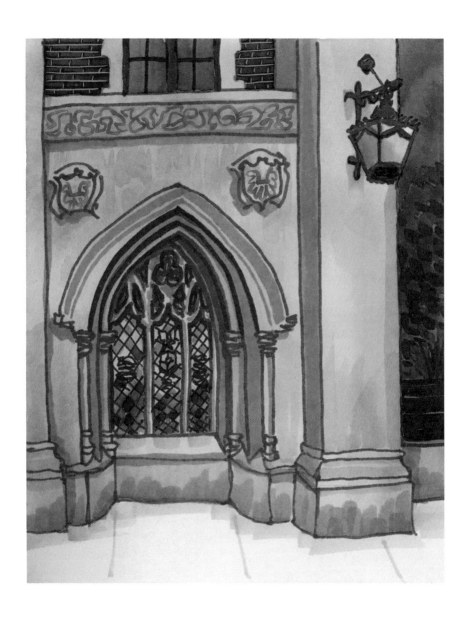

Tudor City Place at 42nd Street, Tudor City, Manhattan

Beekman Place

Just like its sister Tudor City a few blocks south, Beekman Place is nestled on a plateau above the rest of Midtown. It's not quite as unified in its architecture as Tudor City, but it still has a lot of standout buildings. Some of the nicest are quite refined, built in stately brick, with carefully trimmed shrubs. One, at 439 East 51st Street, has a lot of medieval touches, with castle-like stone arches. That's where I saw this exemplary lamp. The tall lampposts on the street itself are elaborate as well. Beekman Place is far enough up that you don't hear the roar of the FDR Drive below, and it sits in a quiet residential enclave. Some notable residents of the pricey homes have included philanthropist John D. Rockefeller III, composer Irving Berlin, singer Tom Jones, and Princess Ashraf Pahlavi of Iran.

439 East 51st Street, Midtown, Manhattan

Japan Society

Japan Society features only a single exhibit at its headquarters every few months, but it always showcases something fascinating, such as the colorful abstract paintings of lesser-known Japanese American artist Kyohei Inukai. It also hosts events, including Japanese language classes and calligraphy lessons. Hidden on a side street next to the United Nations, across from quiet Dag Hammarskjöld Plaza park, the building echoes true Japanese style in its layout and architecture. It features still ponds, wood steps, quiet stones, and sliding doors. The landmarked building, the first example of contemporary Japanese architecture in NYC, was designed by renowned architect Junzo Yoshimura, and opened in 1971. The society itself, a nonprofit dedicated to promoting friendly relations between the United States and Japan, dates all the way back to 1907.

333 East 47th Street, Midtown, Manhattan

City College

Many colleges have a common architectural motif, with matching brick or stone buildings sprinkled across their campus. But few have endorsed this as uniquely as the City College of New York. The buildings are a mottled gray stone with sparkling white trim, evoking austere gingerbread castles. The Harlem campus, which dates back to 1904, is a joy to walk around for this reason alone. But if you're in the know, look for the small gargoyles scattered around on several of the buildings. City College has more than a thousand of them. And best of all, each is a unique character: laughing, crying, mocking, glowering, grinning, studying. Some are said to be caricatures of past professors. All of them complement the castles—and look like they could jump right off the walls.

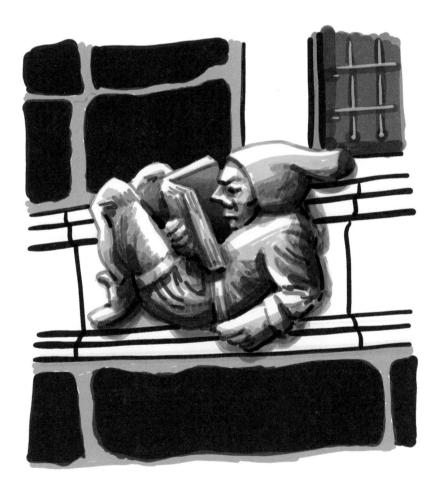

160 Convent Avenue, West Harlem, Manhattan

The Astor Chinese Garden Court

Hidden on the second floor of the Metropolitan Museum of Art, in the Asian Art galleries, lies a re-creation of a Ming dynasty Chinese courtyard garden. It comes complete with trees, an expansive sunroof, and small pools of water. It's one of the quietest spaces in the museum and a great place to just be. Built in 1981, the installation was modeled on a specific scholar's garden in the city of Suzhou, China, called the Garden of the Master of the Fishing Nets. The wood and ceramic materials were all made by hand in China and shipped to New York. The Chinese government had to give special permission to use wood from nan trees, which had once been driven close to extinction and now are harvested very rarely. Also of special note are the rocks, shaped naturally by water erosion into abstract forms, perfect for contemplation.

1000 5th Avenue, Upper East Side, Manhattan

Waterside Plaza

This self-contained apartment complex is really off the beaten path—so much so that it's not even really on Manhattan Island but on a constructed supplement jutting out into the East River. But Waterside Plaza rewards determined visitors who continue past the end of East 25th Street and cross the pedestrian walkway over the roar of the FDR Drive. It's a series of towers with a wide elevated plaza in between, several stories above the ground, with playgrounds, its own stores, space for events, and umbrellaed tables to sit at and watch the vistas of the UN, the river, and Brooklyn. On my uptown commute to work, I'd walk the scenic route along the East River Esplanade, just to cut through Waterside. It's a nice spot to stop and take a breath, and sit up high on one of the benches overlooking the East River, Brooklyn, and Queens.

25 Waterside Plaza, Kips Bay, Manhattan

Green-Wood Cemetery

Green-Wood, a former Revolutionary War battlefield, is a sprawling 478-acre cemetery in Brooklyn. It's well known for its hills and classic statues and crypts, as well as an enormous Gothic castle of an entranceway, shown here. Green-Wood also hosts a statue of the Etruscan goddess Minerva that faces and salutes the Statue of Liberty across the harbor. A more modern area of the cemetery, located near the main entrance, features a tranquil koi pond filled with hundreds of the multicolored fish. And they're not the only living residents. The huge entranceway hosts a giant nest at its peak, home to dozens of bright green parrots. Specifically, monk parakeets, normally native to Brazil and Argentina; it's theorized that the birds escaped from pet store shipments in the 1980s. Now the parrots feast on foraged berries and fruit in the cemetery and can be heard loudly calling out to one another all day long.

500 25th Street at 5th Avenue, South Slope, Brooklyn

The Ford Foundation

The Ford Foundation is like a Russian nesting doll of tranquility. Within Tudor City, one of New York's quietest neighborhoods, sits the foundation's headquarters, a towering office building like many in the city. But within its wide central lobby, open to the public, is a peaceful garden with tiers of different trees and shrubs. And in the middle of that, if you step down through all the greenery, is a small pond with this single, humble tree at its center.

The foundation was started with a gift by Edsel Ford (Henry Ford's son) in 1936, and now has one of the largest endowments in the world, with assets of more than $16 billion. Not affiliated with the Ford Motor Company in any way, it works around the world, focusing on the reduction of poverty and injustice, with a focus on offering grants to support diversity in higher education.

320 East 43rd Street, Tudor City, Manhattan

The Noguchi Museum

Isamu Noguchi was one of the twentieth century's most important sculptors, known for his abstract forms in stone, as well as product and furniture design. He lived a rare dream for an artist: getting to construct your own museum just for your work, to live forever after you're gone. Now the museum itself is considered one of his masterpieces. Located in Long Island City, Queens, this artistic oasis, with its Japanese garden and quiet galleries, offers some of New York's most serene spaces. I like to take my sketching group there in November; certain galleries, are open to the gardens, so you can sketch outside and then dash inside to warm up. This sketch showcases a room filled with giant akari, one of Noguchi's most well-known forms. Akari are lightweight paper lanterns, often round and collapsible. One funny thing about this orderly, precise, minimalist museum is its neighbor, Socrates Sculpture Park. The park is an equally valuable showcase for art, but its outdoor, haphazard collection is messy and chaotic, forming an artsy odd couple with Noguchi's work.

9-01 33rd Road, Long Island City, Queens

Cooper Hewitt, Smithsonian Design Museum

The Cooper Hewitt takes state-of-the-art design in the form of technology, textiles, products, videos—you name it—and places it against the backdrop of the regal Andrew Carnegie Mansion, completed in 1902. Thanks to leading the steel industry in the late nineteenth century, Carnegie became one of the richest people in the world. He then turned into the era's greatest philanthropist, donating nearly 90 percent of his fortune during the last eighteen years of his life—roughly the time he lived in this mansion. The neighborhood hosting the mansion is even known now as Carnegie Hill. The mansion itself is unforgettable, offset by a broad green lawn (lawns stand out in Manhattan). It was one of the first homes to ever have central heating, not to mention its own elevator.

The museum's high-tech touches contrast with the stately mansion. As you climb the plush carpeted staircase with ornately carved handrails winding up toward a chandelier, you can use a digital "pen"—given to each visitor—to scan and save your favorite artworks to review later. A branch of the Smithsonian, the museum held one of its Triennials in 2019, which inspired this glowing iPad sketch. The theme of the exhibit was "Nature," and this fluorescent dress hovering in a darkened room is titled *Fantasma*, by the design studio AnotherFarm. Its spooky glow was created by injecting coral DNA into silkworm eggs and then weaving the transgenic silk into a textile.

2 East 91st Street, Carnegie Hill, Manhattan

CENTRAL
PARK

My drawing group is called the Central Park Sketching Meetup, and even though we quickly deviated from our original location and now draw all over the city, a good portion of our events are still held in the city's largest park. Central Park is known the world round, and its famous mall and Bethesda Terrace are some of the most-filmed locations in the history of television and film. There are other iconic things to do in the park, too, like sailing boats on the Conservatory Water, popping the question on the Bow Bridge, or jogging around the Reservoir.

But that's hardly the extent of the park's treasures. Central Park is so enormous (843 acres!) that it holds many secrets tourists and even locals usually won't stumble onto. The park's winding paths were specifically designed to create a contrast to the city's organized grid, to encourage getting lost and having one-of-a-kind adventures. As you're strolling, you can walk under the park's thirty unique arches, which range from stone to steel to wood. Some of them cross over the park's many bodies of water, which include the obscure Harlem Meer and Loch. There are waterfalls and caverns and ravines buried deep in Central Park's woods. There are statues honoring pilgrims and children's book authors. And there's a glorious wisteria pergola overlooking a fountain and rolling expanse of perfectly landscaped lawn.

Successfully making a beeline for the various locations listed in this chapter can be a little tricky. But any wrong turn is bound to reveal new wonders. Make a long afternoon of it and don't be disappointed if you don't see everything—that's impossible in a densely packed area two and a half miles long. Exploring even a small portion of the park is an experience to remember.

Glen Span Arch

This is one of my favorites of the park's thirty arches. It's impressive, using a perfectly balanced composition of ton-size rocks to hold up Central Park's West Drive. The falling water from the elegant waterfall across from the arch and the trickling stream below it create echoes underneath. Walking under it, on the thin path along the water, you are briefly transported to a dark, mystical cavernous space. The scene shown here is a view of the arch from the top of the waterfall. The original arch, finished in 1865, was actually wooden on top, but the wood lasted only twenty years before it had to be replaced by what is now the arch's trademark stone. The arch gets its name from the area it spans—the small valley of water that used to informally be called The Glen.

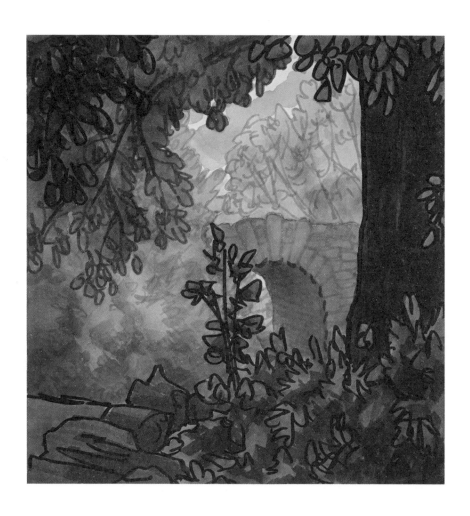

Near West 102nd Street, Central Park, Manhattan

The Ravine

Central Park's Ravine is carved out by the Loch, a stream that runs from Lasker Pool to Lasker Rink. Walking under Glen Span Arch and following the path along the west side of the Loch, you can look down into the Ravine until the path finally dovetails into its end and crosses over the water. The spot is as secluded as any in the park—or in the whole city, really—and boasts an artistic array of rocks, water, and waterfalls, as shown here. The sparkling pools frequently sport small fish, turtles, and crawfish. At the end of the water sits Huddlestone Arch, a squat pile of stones that looks uncarved and practically accidental compared to the intricate detail elsewhere in the park. Green vines hang down gracefully over the rocks, and the water winds underneath, creating a scene that perfectly complements the rest of the ravine.

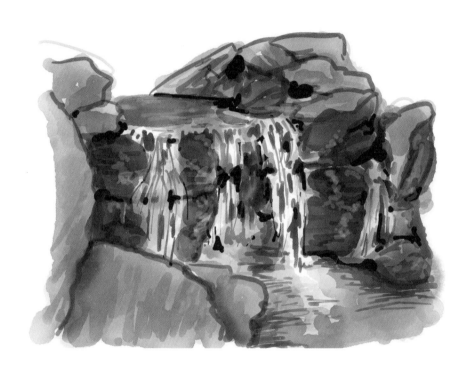

Mid-park near 103rd Street, Central Park, Manhattan

The Pilgrim

Crafted in 1885 by sculptor John Quincy Adams Ward, *The Pilgrim* is exactly what you would expect: a pilgrim confidently commemorating the landing at Plymouth Rock in 1620. True, this did not happen anywhere near New York City, but in 1885 the New England Society in the City of New York commissioned the monument to honor this history. *The Pilgrim* stands away from any path and is easy to miss unless you decide to hike over on the grass appropriately named Pilgrim Hill. The hill is an ideal spot for sledding in the winter or relaxing under the cherry blossoms in the spring.

Since the statue is at the top of the hill, most views of it are from underneath, which is what inspired me to try to capture the unique perspective and dark shadows of this stoic work. Surprisingly, there are three other statues in the park by this same important sculptor: *Indian Hunter*, the 7th Regiment Memorial, and the William Shakespeare monument.

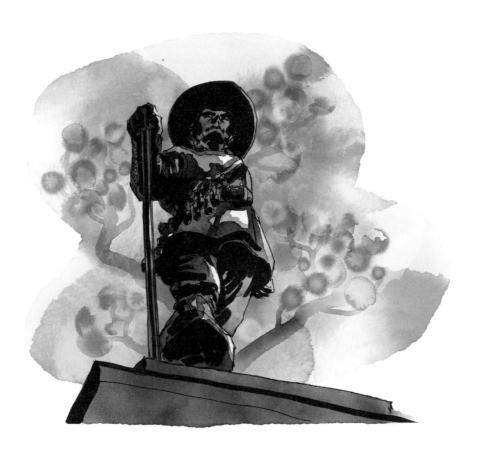

Near East 72nd Street, Central Park, Manhattan

Hernshead

Hernshead is a picturesque, rocky peninsula in Central Park's Lake. The name comes from a British word for *heron*, which the shape of the rock resembles. The adventure of scaling and traipsing over the rocks and sand starkly contrasts with the ornate Victorian structure sitting nearby—the Ladies Pavilion. Designed in 1871 by Jacob Wrey Mould, nineteenth-century Renaissance man and designer of the City Hall fountain, the refined steel-blue pavilion was originally a shelter for trolley passengers. It was located near the long-gone Ladies' Skating Pond, a private ice-skating pond designated for women. I sat on a big rock to sketch this scene of Hernshead and the overcast skyline, but I had to finish the drawing at home. Halfway through, my group was kicked out by two separate wedding parties that had reserved the space.

Near West 75th Street, Central Park, Manhattan

The Conservatory Garden

Central Park is so big and intimidating that most tourists dip their toes into only the attractions right near the southern entrances along 59th Street. This leaves the entire north half of the park empty, save for savvy local residents. One of the most appealing sections of the park is up in East Harlem: the Conservatory Garden. This is actually three gardens, designed in traditional Italian, English, and French styles. And while you're visiting the Conservatory Garden, check out the Museum of the City of New York directly across the street—it's one of the city's best and lesser-known museums, with great rotating exhibits focused on the history of New York.

The Italianate Garden

One third of the Conservatory Garden is classically Italian, with principles of order and balance coming through in its simple central fountain and verdant grass field surrounded by crisply shorn hedges. The highlight is a towering wrought-iron arbor of wisteria forming a curved path overlooking the entire garden.

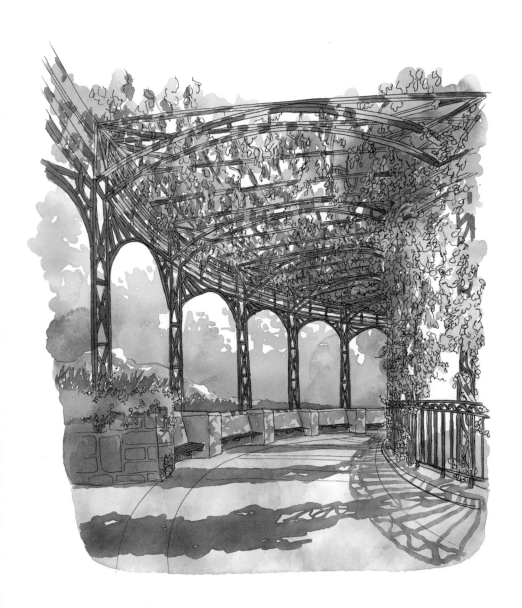

1233 5th Avenue, Central Park, Manhattan

The English-Style Garden

The southern third of the Conservatory Garden
is based on a traditional English planned garden.
It's a circular maze of concentric flowers with a
graceful pool and a tranquil birdbath statue in
the center. The statue is a memorial to the author
of *The Secret Garden*, Frances Hodgson Burnett,
who lived from 1849 through 1924. The young boy
and girl immortalized in the statue are reminiscent
of the characters from the classic book.

The French-Style Garden

A large, open, sunny area in the northern third
of the Conservatory Garden, the French-style
garden arranges flowers in circles around a
central fountain. First, lilac bushes ring the outer
circle, wafting sweet smells during the spring and
summer. Then vines of roses mark the entrance
trellises. Finally, thousands of tulips paint a circular
rainbow, filling the garden with light and color. The
fountain features one of the most-loved statues in
the city, *Three Dancing Maidens* by Walter Schott,
circa 1910. Sometimes children can't help but
join the maidens at the center and stare at their
reflections in the water below.

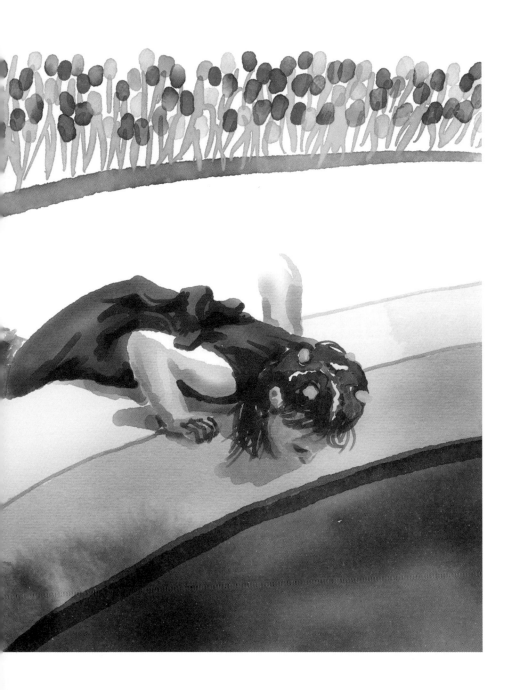

The USS *Maine* National Monument

The USS *Maine* was a battleship that sank in 1898, killing 268 sailors, three-quarters of the crew. The event was remarkable not only as a terrible disaster in its own right but also as a catalyst of the Spanish-American War. At the time, sensationalist newspapers accused Spain of being responsible for the sinking, but that has been found debatable. An investigation in 1974 supported the theory that a spontaneous fire from the ship's unique, highly flammable coal was the true culprit.

This enormous monument—only a small portion of the back of it is sketched here—has sat at the Columbus Circle entrance to Central Park since 1913. Designed by Harold Van Buren Magonigle, it's surrounded by sculptures (shown here) by Attilio Piccirilli, who also created the grand gold statues on top. The model for the female figure in the center, representing Columbia or the Americas, was Audrey Munson, America's first supermodel. The bronze for the statues, as well as the monument's metal plaque, came from the salvaged ship.

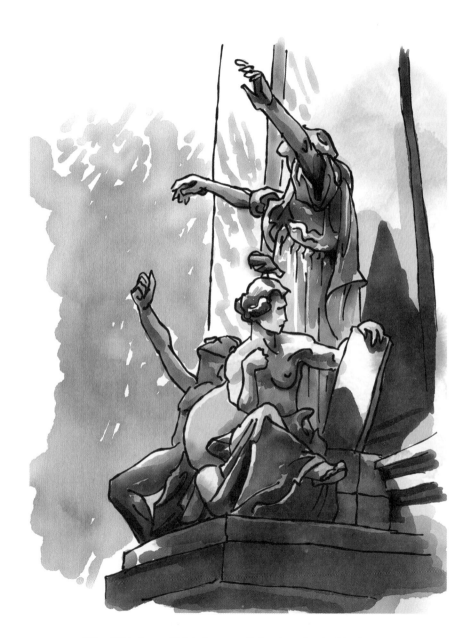

West 59th Street & 8th Avenue, Columbus Circle, Manhattan

Harlem Meer

Of Central Park's bodies of water—Harlem Meer, the Loch, the Reservoir, Turtle Pond, the Lake, Conservatory Water, and the Pond—the Harlem Meer might be the most underrated. It sits at the very top of the park, and is frequented mostly by locals rather than tourists. The water can tend toward the brackish, but it's bordered by wafting cattails that often reveal a duck family or group of turtles. Some nearby trees are perfect for picnicking under, and there's an elegantly paved shady area with benches for resting, people-watching, and drawing. The former boathouse on the north side of the Meer is now an environmental center where visitors can discover information about Central Park and the ecosystem's history.

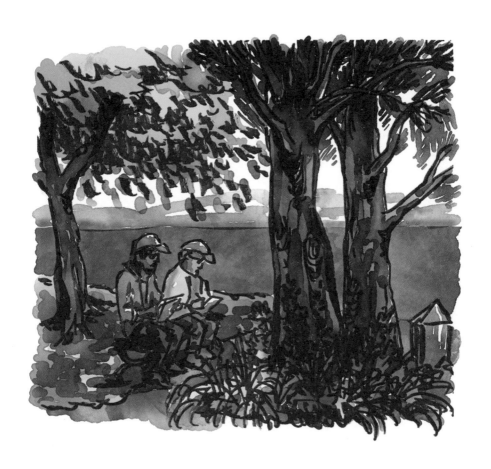

Between East 106th Street and East 110th Street, Central Park, Manhattan

The Last Bolt

You'll never find this bolt unless you're looking for it, and maybe even not then. What's so meaningful about this little thing? Well, the most important development in the history of New York City was enshrined in a single document: the Commissioners' Plan of 1811. This map established the orderly grid of streets, from Houston ("Zero Street") up to 155th Street, that defines Manhattan to this day and has been a big factor in New York's success. It was chief engineer John Randel Jr. who had the job of surveying the land and hammering more than a thousand bolts into the rocky ground, one to mark each future intersection. They're all long gone by now, of course. However, Central Park was conceived and blocked off later, in the 1850s, smack-dab in the middle of the gridded plan area. This meant there was a good chance historians could find one of the original bolts there, and sure enough, one was found in 2004. So intrepid detectives can still find the lone remaining bolt stuck hard in a large glacial rock, sword in the stone–style, behind the Dairy building in Central Park.

Mid-park at 65th Street, Central Park, Manhattan

EXCURSIONS

New York's extensive subway system and other transportation corridors were all designed for one purpose: to move commuters into Midtown and Downtown Manhattan. So it can be a bit tricky when you try to go somewhere on the outskirts—but it can also really be worth it. Most of the locations in this chapter are found in the outer boroughs, so if you happen to live near one, it's not an excursion to you. But since most visitors stay in Midtown, these will commonly require a trip. One is in the Bronx, two are in Queens, and one is on Staten Island. New Jersey is represented, too, along with a special little island in the middle of New York Harbor.

Pier C Park

Opened in 2011, Hoboken's Pier C Park is a bean-shaped island protruding into the Hudson River, connected to the New Jersey city's waterfront by a winding boardwalk bridge. It features a fishing pier, a playground with a tall tower and a water play area, several lawns, and a promenade—and of course, the highlight: wide vistas of the downtown New York City skyline. It even has some of those standing telescopes that require quarters to use. What makes the island particularly unique is that despite its small size, it was designed with hidden nooks and crannies and surprises. You can be walking on a winding path and then with a twist there's suddenly a vista of the water in front of you. The playground is particularly sweet and secret, nestled in a grove of trees. It's like its own little self-contained, bean-shaped park-world.

340 Sinatra Drive,
Hoboken, New Jersey

The Louis Armstrong House

Look how blue this kitchen is! It practically vibrates with plastic brilliance. I imagine it would be like cooking inside a blue raspberry Slurpee. Surprisingly, the former home of the jazz great Louis Armstrong, filled with lots of over-the-top decor, looks mild-mannered from the outside. You wouldn't dream that this brick home resting on a quiet street in Corona, Queens, once housed one of the greatest entertainers of all time. A world-famous trumpeter and vocalist, Armstrong was one of the most "instrumental" figures in jazz history! Though born in New Orleans, Armstrong lived much of his life in New York, and he lived in this home with his wife from 1943 until his death in 1971. The house is now open as a museum, with the main draw being complete preservation. The tour offers charming tidbits about the lives of the Armstrongs, but half the fun is the experience of stepping back in time into a jazzed-up 1960s home. And there are so many idiosyncratic details that reveal the maestro's taste: this radiant kitchen, chandeliers and candelabras, air conditioners concealed by cabinets, and a den of deep wood cabinets filled with antique tape recorders. Knickknacks sit on the shelves, and paintings of Armstrong abound. A final tip: Don't miss the koi pond in the tiny backyard.

34-56 107th Street, Corona, Queens

Governors Island

Just eight hundred yards from Lower Manhattan sits an island that feels like it's much farther away. After stepping off the ferry onto Governors Island, you're transported to a world of wide, grassy fields, forts and castles, abandoned buildings, and towering playground mountains.

A former military base dating back to 1776, the island was decommissioned in 1996 and then opened to the public nine years later. It's packed each spring and summer and hosts concerts, festivals, art fairs, classic car shows, and more. There are so many edifices from different eras to explore there—from the rusty lighthouse pictured here to the huge 1811 circular defense known as Castle Williams. There are colonial homes, a beekeeping exhibit, trendy food trucks serving delicacies from around the globe, and a grove of relaxing hammocks, to name just a few of the wonders.

Ferry from 10 South Street, Slip 7, Financial District, Manhattan

Snug Harbor

Originally built as a home for retiring sailors, this collection of majestically old buildings on Staten Island now contains many cultural destinations. There are the five interlocking Greek Revival buildings known as "Temple Row" that look like you're going shopping for a courthouse. Then there's the Botanical Garden, the Children's Museum, the Staten Island Museum, the Newhouse Center for Contemporary Art, and the Noble Maritime Collection. The site also contains a cemetery and a chapel. Overall, the area, which feels like a large estate or campus, is considered Staten Island's crown jewel.

1000 Richmond Terrace, Staten Island

The Unisphere

Even if you live in Queens, it's an excursion to find your way through Flushing Meadows Corona Park to the mind-bogglingly large atomic globe at its center. The scale of the thing is impossible to capture on paper—the 140-foot-high sphere sits atop a twenty-foot-tall base. That's about eleven stories tall for the whole structure—half the height of the Statue of Liberty! It's the largest representation of Earth on Earth.

Designed by Gilmore D. Clarke for the 1964 New York World's Fair, the Unisphere embodied the fair's theme of "Peace Through Understanding." New York City Parks Commissioner Robert Moses was president of the World's Fair Corporation and commissioned the piece. The once-idealistic Moses was bloated with corruption and power by this late phase in his career, but he pulled off an impressive fair capped by this spectacular centerpiece. Today some of the retro-futuristic buildings still stand, and the huge park hosts the Queens Museum, the Queens Zoo, and the hands-on New York Hall of Science, all of which are well worth a visit.

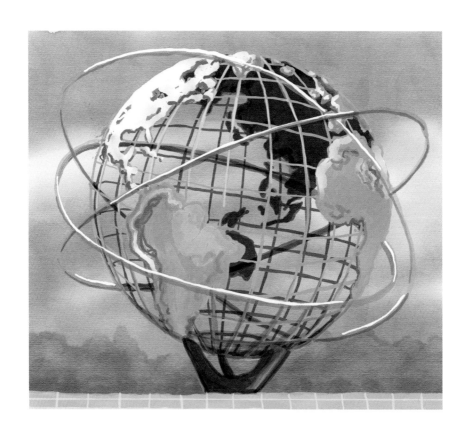

Flushing Meadows Corona Park, Corona, Queens

Wave Hill

"It looks like Capri," said my wife, referring to the beautiful Italian island where we went on our honeymoon. And with the flowers hanging from overarching canopies, the classical columns, and the cliffs across the river, she was right. But those cliffs are in New Jersey, and Wave Hill Public Garden & Cultural Center is in the Bronx.

The surrounding neighborhood is richly suburban with big homes, heavily wooded, and steeply hilled. It's about a mile-and-a-half uphill walk from the nearest subway station, 242nd Street, the final stop on the 1 line, but what a payoff. Wave Hill is a twenty-eight-acre estate open to the public that's lusciously landscaped with world-class gardens. The house on the estate, built by lawyer William Lewis Morris in the early 1840s, now serves as a cultural center. There were some very cool art exhibits, taking over several rooms, when we visited. Outside, my favorite blooms on display were the bountiful hanging wisteria, in both traditional purple and an unusual shade of very light yellow. But the icing on the cake of the whole experience is the view across the Hudson River. A large open field runs up to a classical stone balustrade, and from there the New Jersey Palisades stand imposing across the wide blue river. On a sunny day, it's breathtaking.

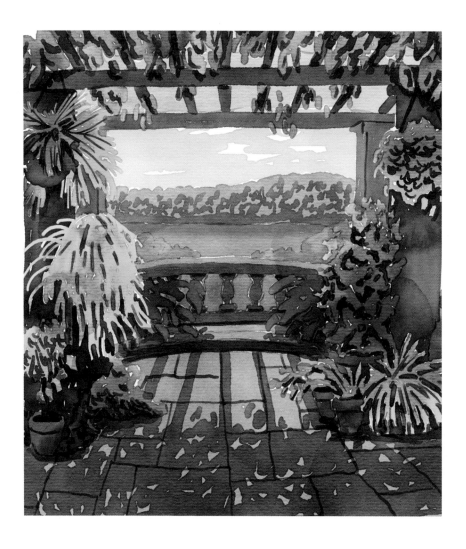

4900 Independence Avenue, the Bronx

So how do you go about finding these New York secrets? Since I can't give every reader a private tour, I tried to put together the next best thing. Here are parts of some of the walks I've developed for visiting tourists and friends. All are in Manhattan but showcase very different aspects of this diverse city, so you can choose based on *where* you want to be or *what* you want to see. First, there's a walk through the excellent park system of Lower Manhattan, with views of the harbor and including historic spots from this oldest part of the city. Then there is a casual walk through local neighborhood parks. Gramercy is one of the most beautiful areas of the city but one not many tourists pass through. Or you can take the Book-Lover's Walk, which goes through bustling Midtown on a shopping spree and library tour. Lastly, you can take a stroll through the best of northern Central Park—the half that's less frequented but no less beautiful. Whatever walk you choose, always keep an eye out for the unexpected!

Downtown River Walk

The entire perimeter of Lower Manhattan is a single continuous park, and one of the most relaxing walks you'll find in the city. Start with **The Real World** (1), a fun sculpture park by artist Tom Otterness. Then explore the crying rock wall at **Teardrop Park** (2), and continue down along the river to see the ships moored at North Cove Marina, where you can also find dining and shopping. If you haven't been to see the 9/11 Memorial, that's only a block east, and it is a powerful and emotional experience not to be missed. The Oculus, a bird-shaped shopping mall, is there as well. From North Cove Marina, continue down to—you guessed it—**South Cove** (3), where you can sit on that bizarre lookout structure. You'll also pass the Museum of Jewish Heritage and the Skyscraper Museum. The park continues with the beautiful **Robert F. Wagner Jr. Park** (4) and its delicately arranged gardens, and then you'll hit Battery Park at the tip of the island. The unique **SeaGlass Carousel** (5) is a blast for both kids and adults (if the line's not too long). Leaving the parks and entering downtown, pass by the historic **Fraunces Tavern** (6), where George Washington dined, and which hosts a Washington museum upstairs. Next to it is the cobblestone **Stone Street** (7), a beautiful row of old buildings and outdoor dining. Just off Water Street you'll find the Vietnam Veterans Memorial, as well as the **Elevated Acre** (8)—the secret park you can reach only via a nondescript escalator. Finally, head up to the South Street Seaport, a historic eighteenth-century neighborhood of restaurants and shops, including the fascinating **Bowne & Co., Stationers** (9).

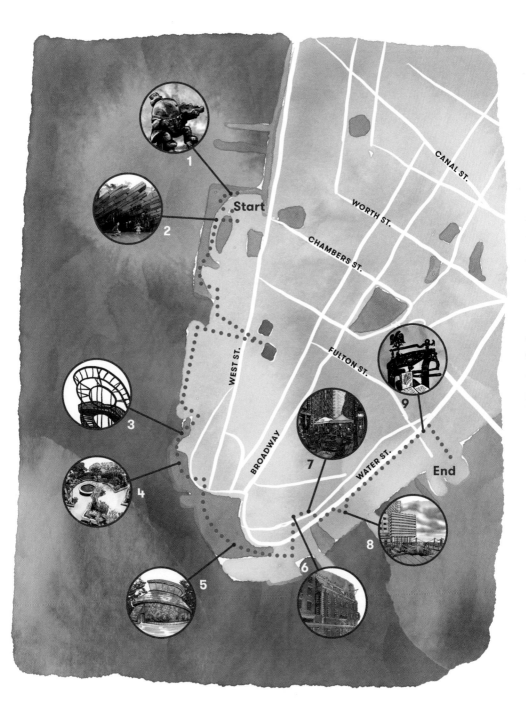

Neighborhood Parks Walk

This walk takes you through four of the city's best neighborhood parks. It will give you a real taste of residential neighborhoods in New York, away from the tourist centers. Start at the delicious David's Bagels on 16th Street and 1st Avenue, then walk into Stuyvesant Town a bit, to experience an oasis of green. Coming out at 18th Street, you'll pass a spooky **Haunted House** (1), and then head over to the charming **Stuyvesant Square** (2). Next to the park is **St. George's Church** (3) as well as Quaker properties and beautiful ivy-covered buildings on 16th Street. Next, walk up 3rd Avenue to 19th Street and experience **Block Beautiful** (4), an architectural wonder. One block up is Gramercy Park—you won't be able to get into the locked park, but the tree-lined streets host incredible historic mansions to admire. Then head down Irving Place to Union Square, a hub of activity: students protesting, chess players, musicians. Several days a week there's a farmers' market and rows of artists displaying their works. One block below Union Square you'll see the intricate **Roosevelt Building** (5), and if you like, you can stop in the world-famous Strand bookstore, or comic book store Forbidden Planet. Head back up to Union Square to see statues of Washington, Lincoln, and Gandhi. Walking north on Broadway, you'll see lots of great architecture and places to shop, as well as the best ground-level view of the Empire State Building in the city. Finally, you'll end up at the Flatiron Building, where you can go down into the subway to "try on" some **mosaic-tile hats** (6). Or visit the Harry Potter store, then grab a bite in Madison Square Park at the original Shake Shack.

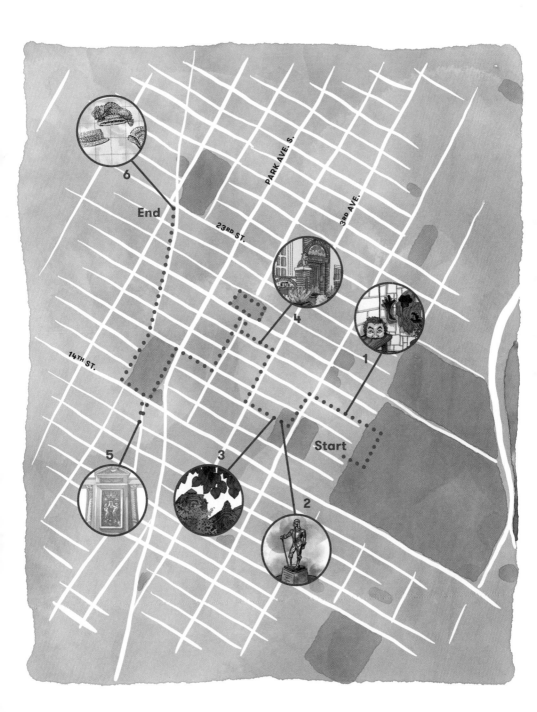

Midtown Book-Lover's Walk

Midtown may be Tourist Central, but that doesn't mean it doesn't have a lot of hidden gems. This walk is fun for everyone, but bibliophiles will get a particular kick out of it. It starts with two of the best bookstores in the city—first, the **Drama Book Shop** (1), then **Kinokuniya** (2), whose second-floor café overlooks gorgeous Bryant Park. Walking through the park will bring you to the main branch of the New York Public Library. Definitely check out the exhibits on display, especially the original **Winnie-the-Pooh** toys in the Polonsky Exhibition (3). Next, walk east on 41st Street and you'll see many plaques with inspirational quotes from books—this is "Library Way." Head down Park Avenue to the stunning **Morgan Library** (4) to see both the art museum and the library's antique book collection, including an original Gutenberg Bible. Walking back up Park Avenue, go inside Grand Central if you've never been and appreciate the ceiling full of constellations, then exit through their delicious market out to Lexington Avenue. Continue east on 42nd Street and stop in the lobby of the **Daily News Building** (5) to see Superman's *Daily Planet* globe. At 2nd Avenue, switch to 41st Street to walk up to the elevated **Tudor City** (6) neighborhood. It's got surprising castle-like architecture, two serene parks, and a bridge over 42nd Street that gives you a great view of the Chrysler Building and the United Nations. There are some nice benches so you can sit and dig into whatever books you bought along the way. If that's not relaxing enough for you, check out the lobby of the **Ford Foundation** building (7), a meditative garden open to the public.

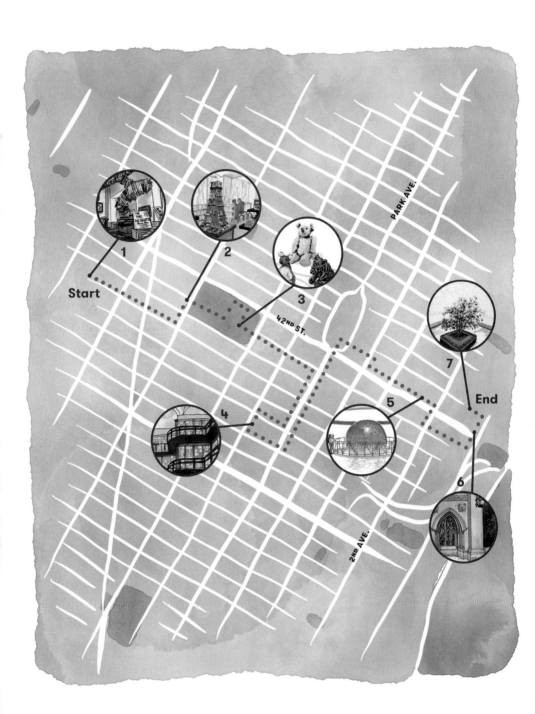

Start

1

2

3

PARK AVE.

42ND ST.

7

End

4

5

6

2ND AVE.

Hidden Central Park Walk

Some of the best parts of Central Park are in its less well-worn northern half. For this walk, start at 103rd Street on the West Side—there's a B/C subway stop there. Walk down the hill past the Pool until you're on a little rustic bridge. From there, climb down the rocky path and look behind you at the beautiful waterfall (yes, there are waterfalls in Manhattan). Then walk under the majestic stone **Glen Span Arch** (1), following the Loch, a quiet stream through the forest. It will bring you to a scenic spot called the **Ravine** (2), with a second, smaller waterfall. Continue under the cave-like Huddlestone Arch until you see Lasker Rink, a huge ice-skating rink in the winter and public pool in the summer. Stay right, and if you like, you can walk up to the elevated Nutter's Battery or Fort Clinton, two Revolutionary War outposts. Walk down to the edge of **Harlem Meer** (3) and now you're at the east side of the park. Re-enter at 105th Street for a majestic view of the formal Conservatory Garden. It's split into three parts: the tulip-encircled dancing statue of the **French-Style Garden** (4), the wisteria-covered ironwork of the **Italianate Garden** (5), and the flowering paths of the quiet **English-Style Garden** (6). If you still feel like doing some walking, head down to the famous Reservoir, a popular spot for taking some exercise. Along the way, stop in any number of world-class museums along 5th Avenue between 105th Street and 82nd Street—Museum Mile.

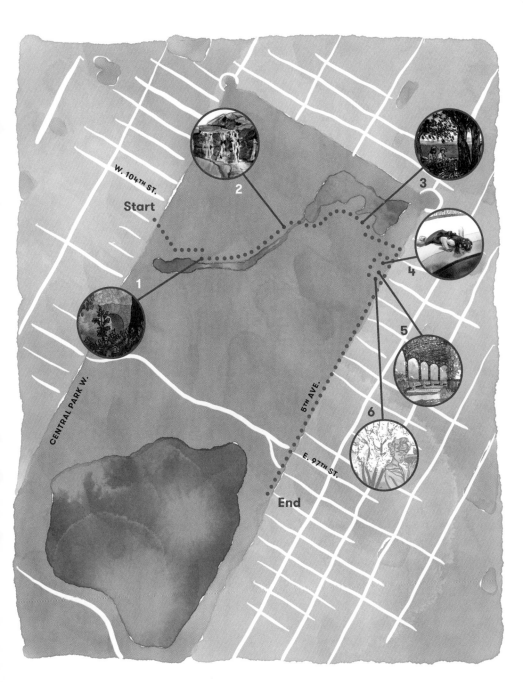

ACKNOWLEDGMENTS

Above all else, I am indebted to my parents, Janet and Rodney Richards, for encouraging the artistic direction of my life. I am also immeasurably grateful for my wife, Rachel, for always appreciating my art and encouraging me, as well as supporting my Meetup and greeting schedule. And I'm grateful for my daughter Sienna Rose, for all of her artistic inspiration. I love our family sketch meetups!

A big thanks to Mary Ellen O'Neill, my editor, for all of her direction and suggestions, and our work together to make this the best book it could be. Everyone at Workman has been incredible to work with, including Beth Levy, Sarah Smith, Galen Smith, Barbara Peragine, Julie Primavera, and everyone in marketing and publicity. And thank you to my agent, Michelle Tessler, who took a second chance with my book and then did her job so effectively and quickly it blew me away.

I am grateful to the many members of the Central Park Sketching Meetup, including regulars like Brianna Collins, Cheri Dannels, Russell Eike,

Dave Pinter, Stephanie Colombo, Janette Rozone, Danna Feintuch, Erin Sawaya, Jerry Chen, Phil McDonnell, Bryce Prevatte, Hans Hansen, Daniel Jay, and many more. Your work is inspiring and has driven me to improve, and your friendship is even better. Kathryn Cross, besides being a talented artist, your tireless work supporting others makes you a real hero. I want to thank all of the members of the group, even if you've only attended once: I'm glad you could contribute and add your creative energy. And thank you, Simon Levenson, for the collaboration and fruitful walks. I also want to thank Meetup.com and its founder, Scott Heiferman, without which the group couldn't have existed. And the biggest thanks for the group goes to Tom Kovalski, for having such a good idea at the beginning.

I am indebted to Lawrence Miller, for being the single person most responsible for the direction my adult life has taken, by suggesting we move to New York City. And to Jon Zack, for letting me keep my job back when working from home was a strange idea. I also really appreciate Big Apple Greeter and its hardworking team, and the city officials who help fund the program. I found many of the places for this book while researching my greets. And thanks to the talented Les Barnett, for inspiration and for his hospitality. I am also constantly grateful and surprised by the Instagram and YouTube communities who follow my work—thank you for all the kind comments, they're truly encouraging.

Lastly, I want to honor Susan Stark's memory. Susan was a talented watercolorist in the sketch group for many years. Never afraid to speak her mind, she encouraged my work and became a good friend. Thank you, Susan, we all miss you.